Zentangle®

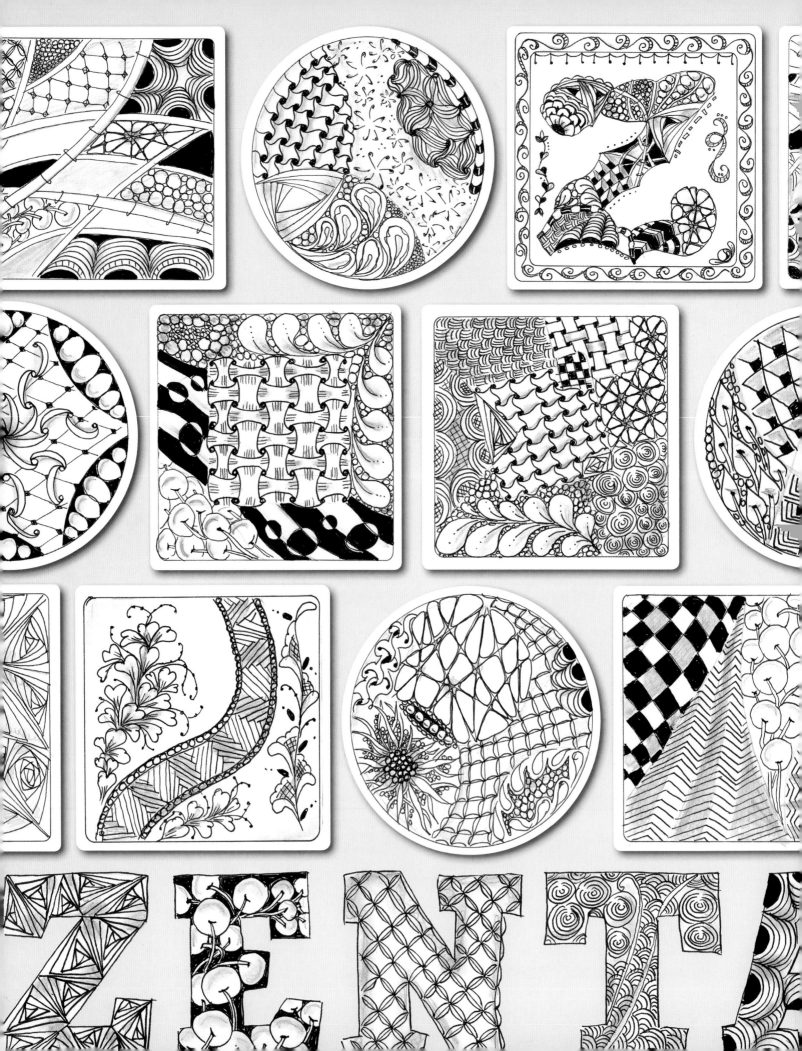

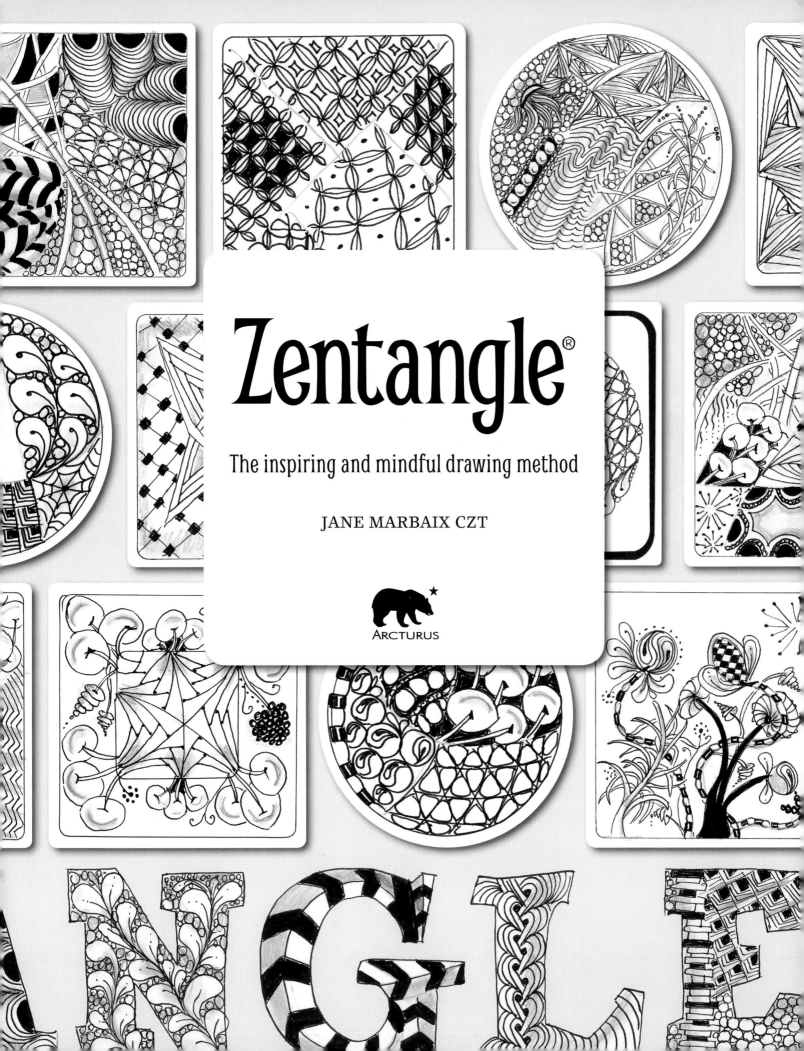

Zentangle®

The inspiring and mindful drawing method

JANE MARBAIX CZT

ARCTURUS

Acknowledgements:
I would like to thank my friend Jamie Malden of colouricious.com, who told
me about Zentangle and organized my early workshops at her home; and Rick
Roberts and Maria Thomas, who taught me a skill for life.

'Zentangle'®, the Zentangle logo, 'Anything is possible
one stroke at a time', 'Bijou', 'Certified Zentangle Teacher',
'CZT'®, 'Zentangle Apprentice'®, and 'Zentomology' are
trademarks, service marks or certification marks of Rick
Roberts, Maria Thomas and/or Zentangle, Inc.

PERMISSION TO COPY ARTWORKS: The written
instructions, designs, patterns and projects in this book
are intended for the personal use of the reader and may
be reproduced for that purpose only. Any other use,
especially commercial use, is forbidden under law without
the written permission of the copyright holder.

This edition published in 2015 by Arcturus Publishing Limited
26/27 Bickels Yard, 151–153 Bermondsey Street,
London SE1 3HA

ISBN: 978-1-78404-284-4
AD004259UK

Printed in China

CONTENTS

What is Zentangle? 6

First Steps 8

Zentangle Inspired Art 17

Tanglenhancers 20

Zentangle Friends 21

Tangling Fun 24

Using Stencils 29

Zendalas 40

Shapes 44

Letters and Numbers 46

Rubber Stamping 50

Kids' Time 54

Directory of Tangles 63

What is Zentangle?

'The Zentangle Method is an easy-to-learn, relaxing, and fun way to create beautiful images by drawing structured patterns.'

These are the words of Zentangle's creators, Maria Thomas and Rick Roberts. Maria is a talented lettering artist and Rick is the zen of the partnership, having lived as a monk for 17 years. Rick noticed that while Maria was working at her art she was in a very calm state, totally focused on what she was doing. They set about breaking down the patterns they created in an easy-to-follow format so that anyone – artist or not – could create beautiful images by repeating the patterns. Thus the Zentangle Method was born.

'Anything is possible, one stroke at a time' has become a Zentangle slogan – part of a philosophy that has brought the benefits of the exciting art form that is Zentangle to many people. My own adventure with it began when I went to the USA to study with Rick and Maria. I was intent on getting the most out of Zentangle for myself, but the realization that my enjoyment of it could be shared led me to start teaching it in classes and workshops.

Zentangle is more than just a form of art – it helps to release stress, is very calming and offers enormous pleasure. The aim of this book is to show that the Zentangle Method is easy to learn and that lovely results can be achieved even if you have no drawing skills – Zentangle has a happy knack of bringing out the artist in everyone. One of the keys to Zentangle art is always to take your time – go slowly and relax. The focus is on the present moment, never on the result; on the journey, not the destination.

an original

zentangle®

zentangle.com

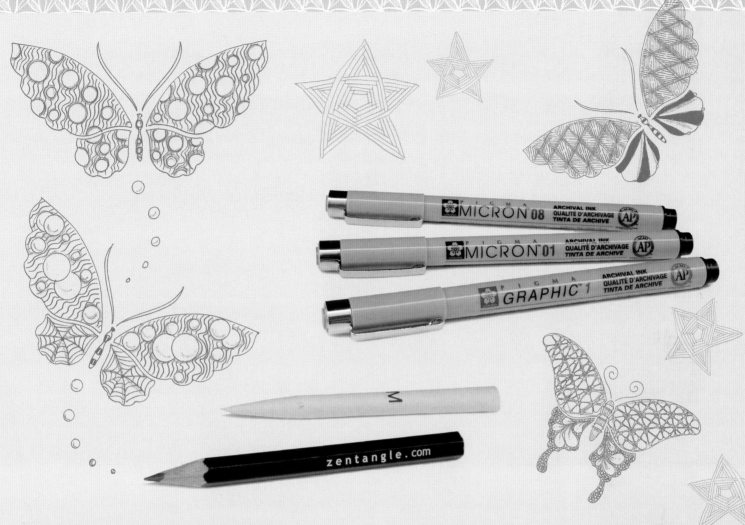

Zentangle art is created on a tile which is 9 cm (3½ in) square. The official Zentangle tile, which is undoubtedly the best, is created from Fabriano Tiepolo paper (available from good art shops and also online). Some tanglers just use a good-quality card stock, as I have done for this book.

You can begin making tangles (patterns) with just a soft pencil, an 01 (0.25 mm) black pen (Sakura Pigma Micron are the best I have used), and a blending stump. You might also like to have an 08 (0.50 mm) pen or a Pigma Graphic 1 for the darker areas. I also use stencils, rubber stamps, protractors and a compass for larger pieces; anything bigger than 9 cm (3½ in) square is categorized as Zentangle Inspired Art (ZIA). A good starting point is the kit available from www.zentangle.com. It comes in a handcrafted box containing everything you need, including a DVD with a demonstration by Maria.

Try to set aside some time each day to practise the tangles. I always take a little blank-page notebook (I love Paperblanks) and a pencil and pen with me wherever I go, just in case I get an opportunity.

Zentangle art is suitable for all ages from about four years upwards. It is very calming for children to have time set aside to tangle, and it improves their concentration and handwriting as well. The oldest student I have had was 97. Zentangle really does make a difference to everyone who tries it.

Now let's get started!

First steps

In the Zentangle Method, tangles (patterns) are broken down into simple steps so that it is easy to re-create each tangle. Each tile (or square) is divided into spaces and each space will have a different tangle in it. There are many tangles to choose from. In the tiles below, Crescent Moon, Static, Tipple and Florz are used, all of them original Zentangle patterns created by Rick Roberts and Maria Thomas. Most of the tangles in this book are Rick and Maria's original tangles, because they are deconstructed for you to follow in the simplest way possible and are therefore ideal for beginners. In time you may be able to create your own tangles, but for now follow the steps and experiment with drawing 'strings' or shapes on the tiles to see what interesting images can emerge.

Tile No. 1 with Z string

We shall start by doing two tiles with set patterns to make it easy for you to follow.

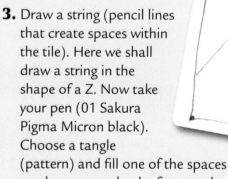

3. Draw a string (pencil lines that create spaces within the tile). Here we shall draw a string in the shape of a Z. Now take your pen (01 Sakura Pigma Micron black). Choose a tangle (pattern) and fill one of the spaces you have created – the first tangle we are using is Crescent Moon, which is a good example of a halo (see the second illustration of the step out opposite). For each space on the tile, use a new tangle.

1. Pick up your pencil and draw a dot in each corner of your tile.

2. Join the dots up lightly with your pencil to form a border.

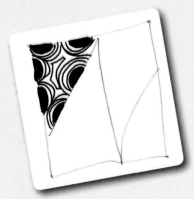

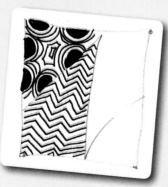

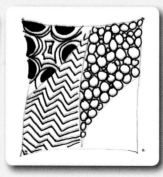

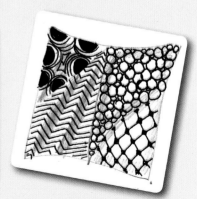

4. In the first space, draw Crescent Moon.

5. Next, draw Static. This tangle is enhanced by the shading, which gives a 3D effect.

6. Then draw Tipple – a very useful pattern for filling in spaces.

7. Lastly draw Florz, a very easy grid pattern when you need a fairly light tangle.

The step-outs below show you how to make the tangles for Crescent Moon, Static, Tipple and Florz.

Crescent Moon

Static

Tipple

Florz

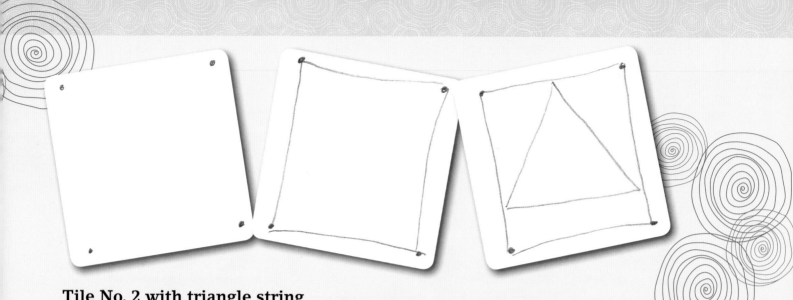

Tile No. 2 with triangle string

Start this tile in the same way as the first one, by making a dot in each corner and drawing a line between the dots. The string this time will be in the shape of a triangle, but this will still give you four spaces in which to draw your tangles.

In the first space draw Poke Root. This lends itself to some lovely shading to make it appear rounded. You will find that you can draw it large or small or a mixture of both.

The next tangle is Hollibaugh – this fits in the triangle space. It is one of the most relaxing tangles to use and is very versatile.

Next is Msst – this looks best if you get the curves to follow each other. Vary the lengths and the distance between the dots underneath.

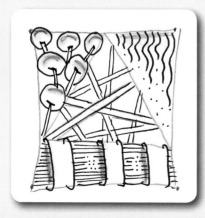

The final tangle shown here is Zander, which is great to shade. Follow the curves of the 'bands'. A highlight can be created by leaving gaps in the lines.

Rotating your tiles occasionally while you work makes drawing the tangles easier and allows you to see and admire them from a different perspective. When you have finished them, add some shading with your pencil. Lastly, put your initials on the front of the tile and sign and date it on the back.

Admire!

Step outs for Poke Root, Hollibaugh, Msst and Zander tangle.

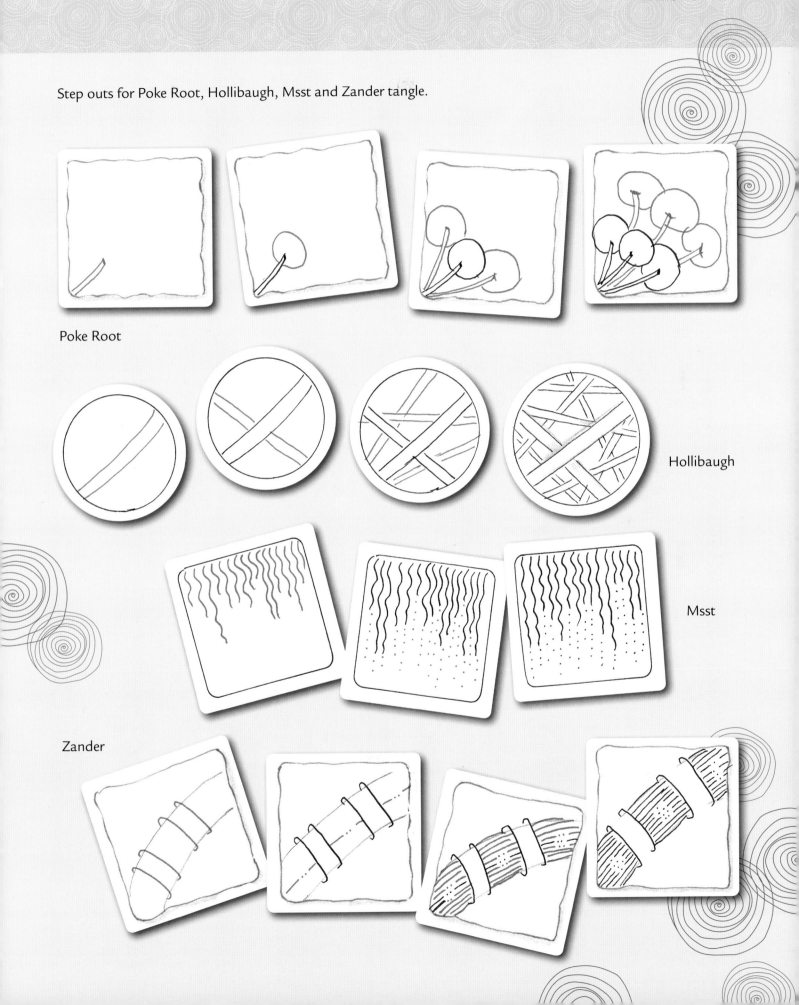

Poke Root

Hollibaugh

Msst

Zander

Inspiration from an expert

This tile was created using TanglePatterns String No. 100 by Maria.

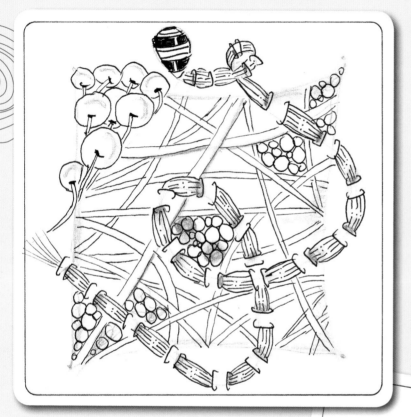

The tangles used on the first example are Poke Root, Hollibaugh, Zander and Tipple.

The second tile has been completed using Paradox, Msst, Tortuca, Braze, BB, Jetties, Flux, Mooka and Poke Leaf.

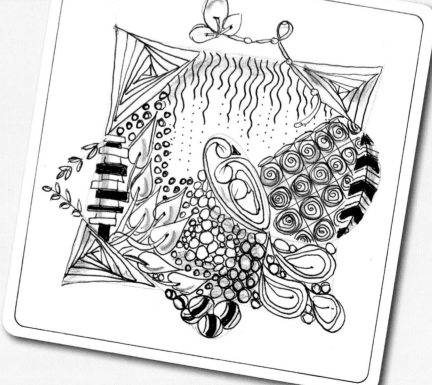

Creating strings

The string is the foundation of your artwork. This is what really defines the difference between a doodle and a Zentangle. In a Zentangle you are creating spaces in which to put your patterns. However, a string is only a guideline. You don't need to keep strictly within its borders – feel free to go over the line or make a new string as you go along.

We started with a simple Z string and then a triangle string to create four separate spaces. We can now progress to a random string that we make up ourselves.

Inspiration for strings

If you aren't feeling that confident, or want ideas for strings, you can go to www.tanglepatterns.com for inspiration. Its creator, Linda Farmer CZT, has probably done more to promote Zentangle – after Rick and Maria – than anyone else. Log on to her website and you can subscribe for free to her mailing list. Once you are a subscriber you will be sent a new tangle or string or a reminder of previous tangles. Linda produces e-guides on strings, a beginner's guide and an annual tangle patterns guide. The last is especially useful as it provides a visual reference to the tangles. If you get the Zentangle bug you will find Linda's site an invaluable resource.

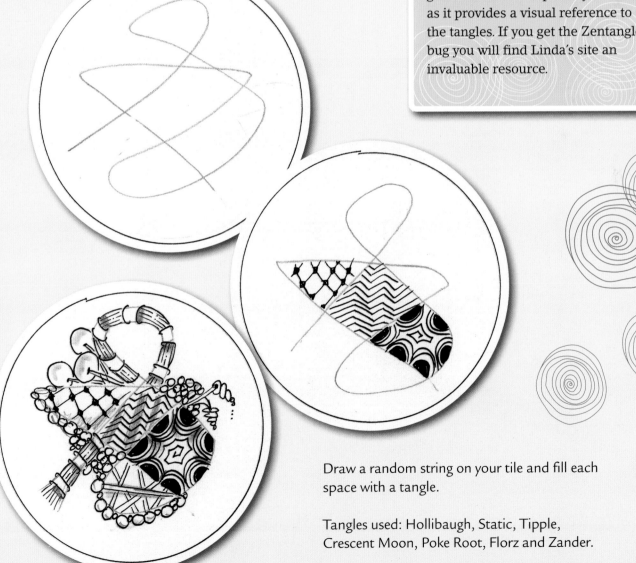

Draw a random string on your tile and fill each space with a tangle.

Tangles used: Hollibaugh, Static, Tipple, Crescent Moon, Poke Root, Florz and Zander.

Tile No. 3 with random string

Our third starter tile is created with a random string. Before we look at this in detail, let's practise. Just take your pencil and go with the flow, creating a string with several spaces. The string is only a guideline – feel free to go outside the lines or to create new lines as you go along. This is very liberating and every time you create your own string it will have a different shape. The strings can be curvy lines or straight lines or a mixture of both. Here are three examples of random strings.

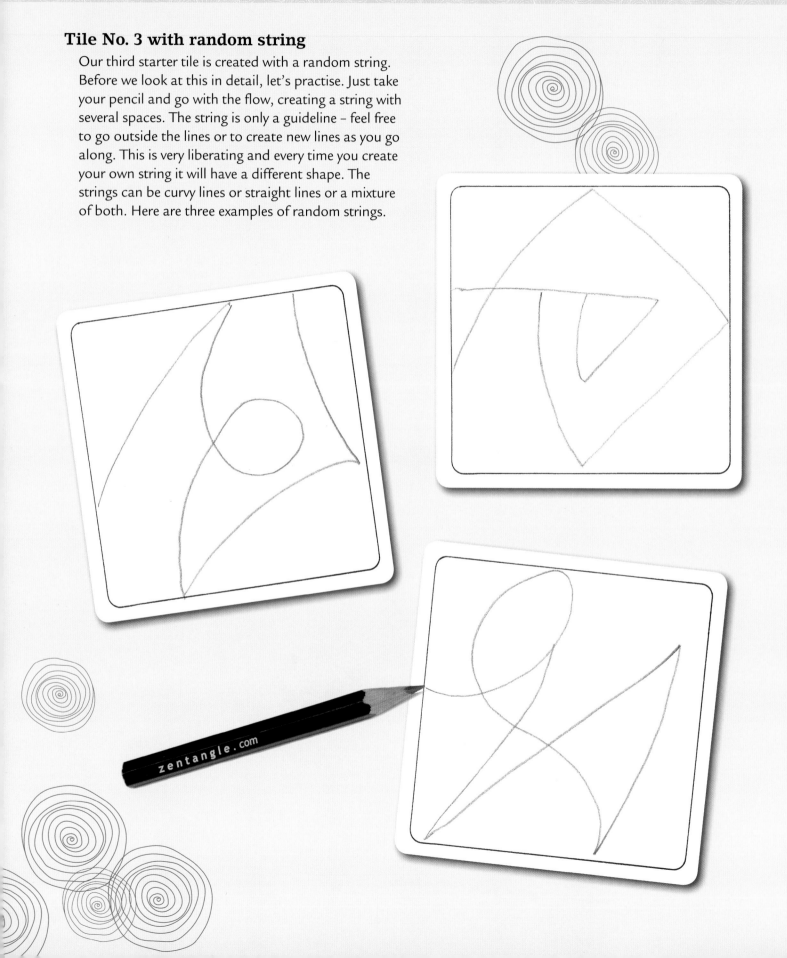

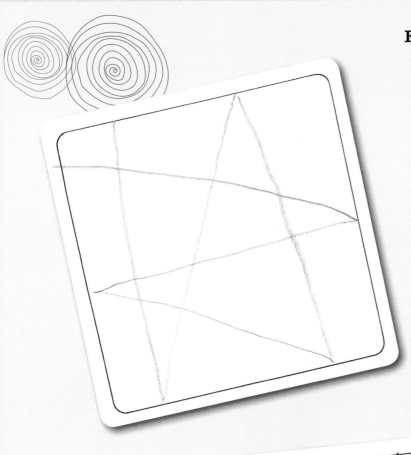

Exercises with random strings/1

Now let's look at a couple of examples of filling in a tile starting with a random string. This first string was created from straight lines. The tangles used are Zander, Florz variation, Hollibaugh, Static, Crescent Moon, Tipple, Bales and Poke Root.

The small owl has a string ready for tangling on its body. Try it!

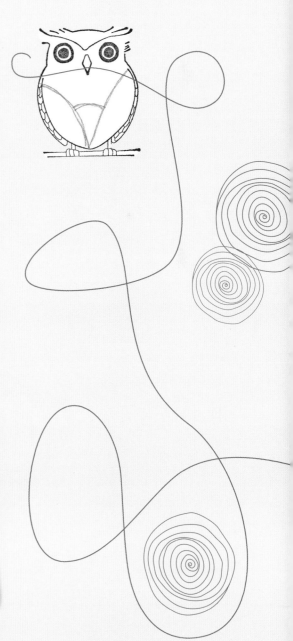

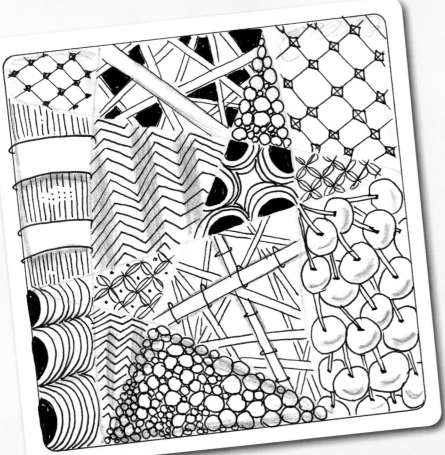

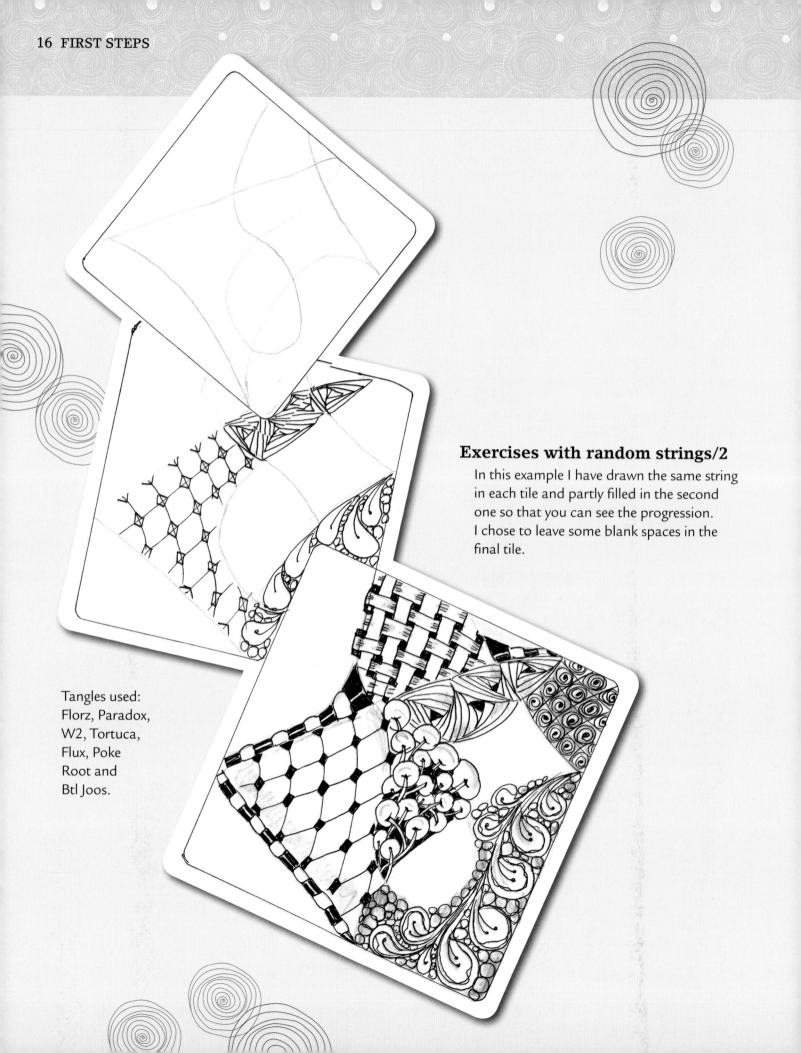

Exercises with random strings/2

In this example I have drawn the same string in each tile and partly filled in the second one so that you can see the progression. I chose to leave some blank spaces in the final tile.

Tangles used:
Florz, Paradox,
W2, Tortuca,
Flux, Poke
Root and
Btl Joos.

Zentangle Inspired Art

Zentangle Inspired Art, or ZIA, is a larger artwork using a random string. Create your string, take a look at what you have drawn and then decide where to start and which tangle to use – some tangles will fit better in certain spaces, so choose carefully. Go over the lines if you like or add enhancements as I have done around the edge.

Tangles used:
Zander, Festune,
Poke Root,
Zinger, Btl Joos,
Paradox, Static,
Braze, N'Zeppel,
Betweed, Flux,
Msst and Cadent

Have fun!

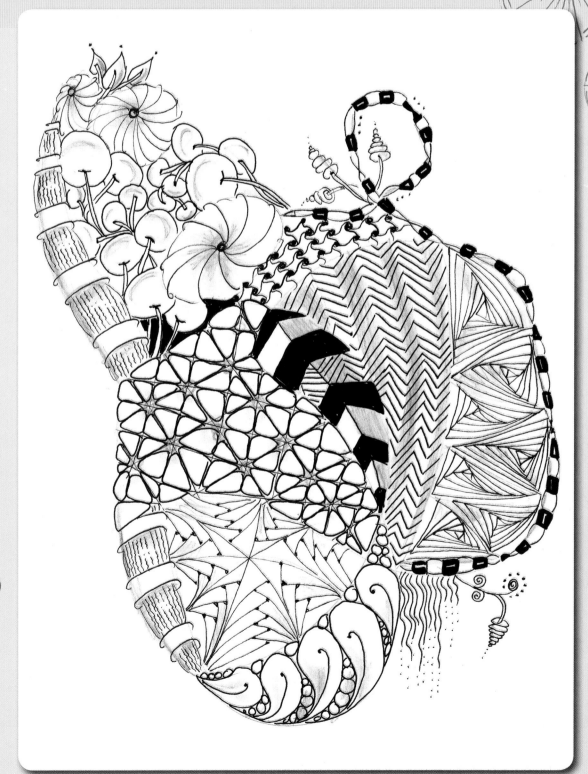

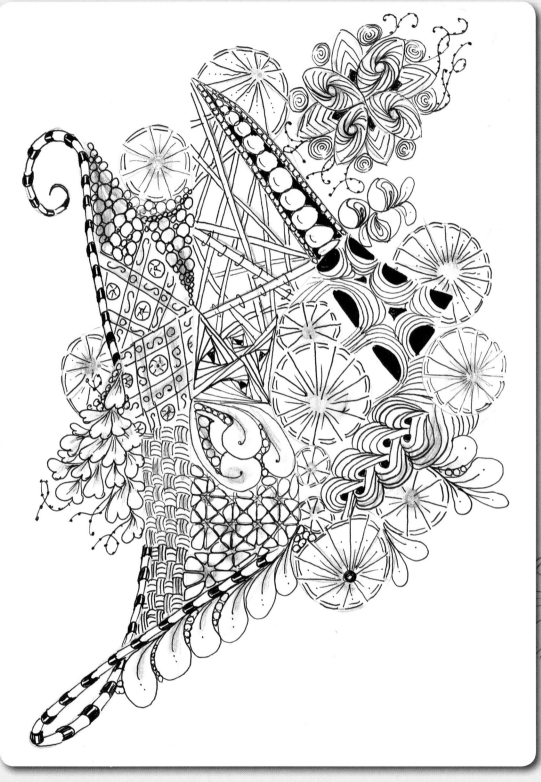

Tangles used:
Btl Joos, Flux,
Marbaix, N'Zeppel,
Paradox, Crescent
Moon, Sparkle,
Hollibaugh, Tipple,
TA-SF, Keeko,
Luv-a, Heartrope
and Cruffle.

With this string I created a lot of different-shaped spaces. I started filling them with patterns, occasionally changing the string or going outside the lines. Then I decided to feature my circular tangle, Marbaix, nine times. If you rotate it clockwise you may be able to see it as a wheelbarrow, like I do – oh well, it's all in the imagination!

'Creativity is the power to transform little into much'

Very often I pick up one of the angel cards that I keep in a little bowl. Some are just one word, such as Forgiveness, Transformation or Play (I like that one!), and some are quotes. As I was starting this ZIA I picked up an angel card with the above saying on it. I thought it aptly described the art of Zentangle.

I drew the outline with a compass and then drew a string. In this instance I started the tangles at the bottom working upwards and then did the shading to finish the drawing.

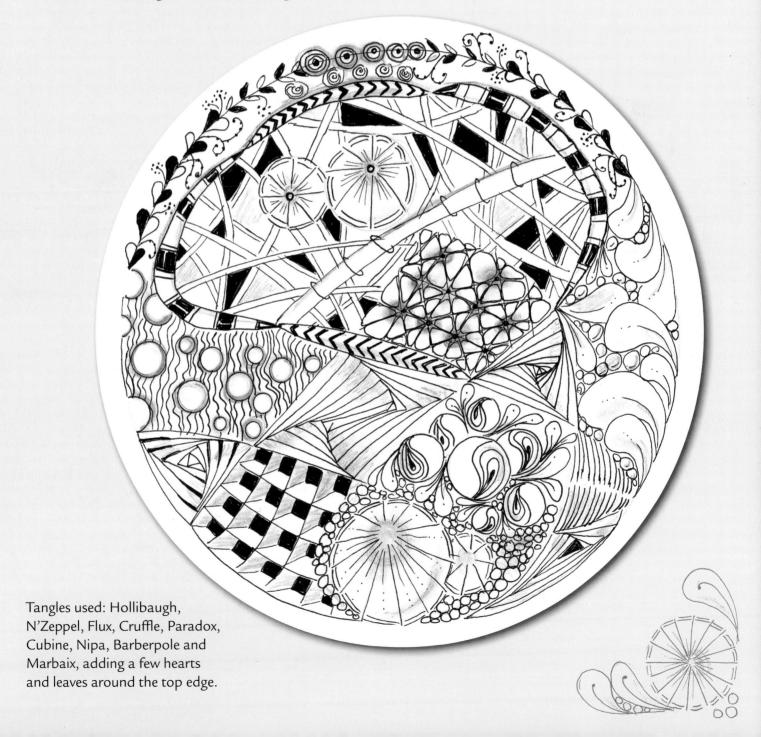

Tangles used: Hollibaugh, N'Zeppel, Flux, Cruffle, Paradox, Cubine, Nipa, Barberpole and Marbaix, adding a few hearts and leaves around the top edge.

Tanglenhancers

There is a range of techniques you can use to further enhance your tangles once you have created the basic patterns. Let's look at them in turn:

1. Shading – This gives dimension to your tangle, and will make it 'pop'. The shading might be rounded or flat or follow certain lines, such as in Static. Use your pencil for shading.

2. Sparkle – Pause while drawing your tangle, leaving small breaks, such as in Printemps. The highlight this creates can magically transform your pattern.

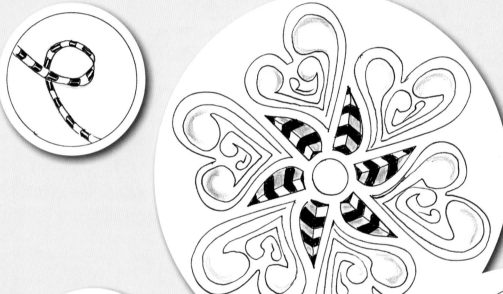

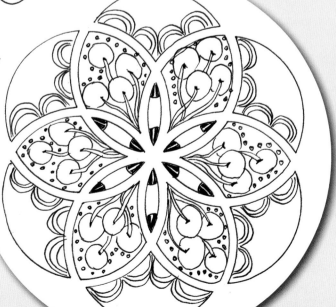

3. Aura – Trace round your tangle to add an aura or echo. You can include multiple auras.

4. Perfs – These are pearl-like dots or circles. It's important not to hurry them – do them very deliberately.

The enhancements shown were drawn using stencils. Tangles used: Poke Root, Braze and Mooka.

Zentangle friends

I have met some inspiring people on my Zentangle journey. One person who has been really influential is my friend and fellow CZT Dr Lesley Roberts.

Lesley has taught the Zentangle Method since 2012 alongside her work as a psychologist. She helps people move on from being stuck, lost and confused by the difficulties and challenges that they face in life.

The importance of being calm, present, creative and confident and achieving potential is enshrined in the principles and values on which the Zentangle method was founded. I asked Lesley to tell me about her experience with it.

'The more I see how this meditative, mindful drawing practice helps people to develop individual resilience, the more I am in awe of it. I have seen that it is particularly helpful for those who find it hard to sit still, concentrate, meditate and relax, as well as for those who just want some creative time out.

'I am passionate about the way Zentangle helps people to be creative and to quickly and easily gain control over thoughts, moods, emotions . . . and, ultimately, life. Stopping your day for 15 minutes to 'tangle' is a simple yet powerful way to gain more control over what you think and feel. Psychologists call this ability to shift one's mood 'self-regulation', and it is a key skill for well-being and emotional intelligence.

'What is particularly magical about Zentangle is that the more you tangle, the more you become habituated to it, and the benefits occur more quickly. Your mind and body recognize what you are doing and move more quickly into the calm state they associate with tangling.'

'When Hollibaugh meets Crescent Moon'

Lesley Roberts created these beautiful tangles for me. She is a master of getting the tangles to marry up or at least go on a date! You don't need to use a lot of tangles to create something beautiful.

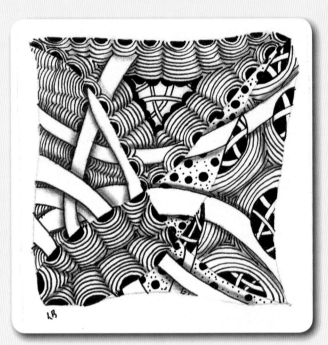

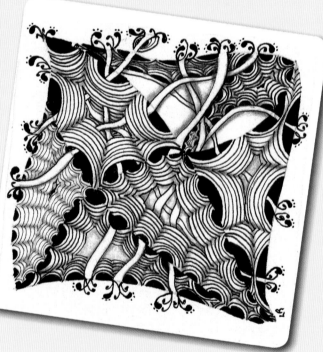

Once a week I teach in a care home in Cookham Dean, not far from London. It is a very beautiful place on a hill and you can see for miles from the room where I hold my class, with a view of Windsor Castle in the distance. I have taught various ladies in the last year. Some lack confidence, thinking the work they do is too shaky. But shaky is good – it doesn't matter.

One lady who never fails to come to the class is Iris, aged 88. When she was young she liked to draw. Now she enjoys learning to do various patterns. Zentangle absorbs her, makes her feel totally relaxed and takes away any stress. At the end of each session she feels fulfilled, with a sense of achievement. Here is some of her work.

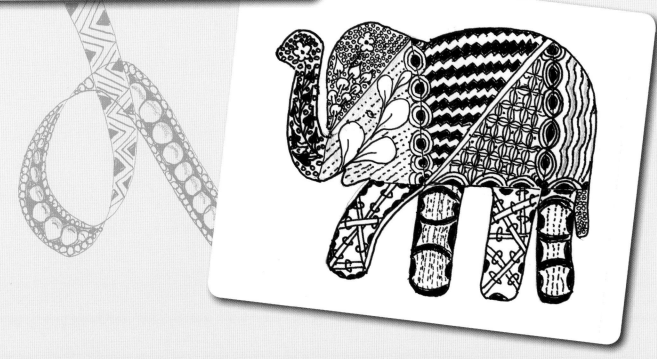

Tangling fun

One of my former students, Lyn Dines, now based in Colorado, devised this flapper girl idea, which I loved. Here are the key stages for you to try.

I used a circular protractor to draw a circle in pen; a CD or circular stencil would work as well. I moved the protractor down and drew a semi-circle to form a band and then two lines for her neck. I divided the face with pencil lines to give me an idea of where the eyes and mouth should go and then put these in loosely in pencil.

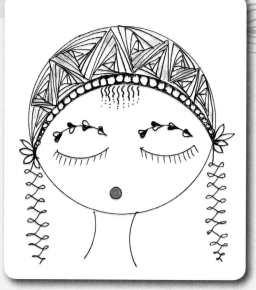

When I was happy with the shapes, I used pen to put in the features properly and then began to draw the tangles. I added a small band in front of the larger one to do a tangle called Btl Joos.

If you wanted, you could draw several different versions, changing the look each time, as I have done here.

From flapper girl to Caribbean lady

Here I have adapted the flapper girl to give her a more Caribbean look.

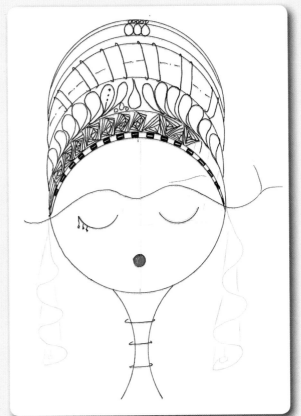

In the first sketch you can see how to build the picture using a circular template (protractor, CD or compass).

Start off the same way as you did with the flapper girl, drawing a circle with your protractor or disc, this time moving upwards and putting in as many 'bands' as you like.

You could draw a faint line across the face to give you a placing for the eyes. You might find it easier to draw the earrings in pencil first, depending on how complicated they are. Now choose your tangles and begin the transformation.

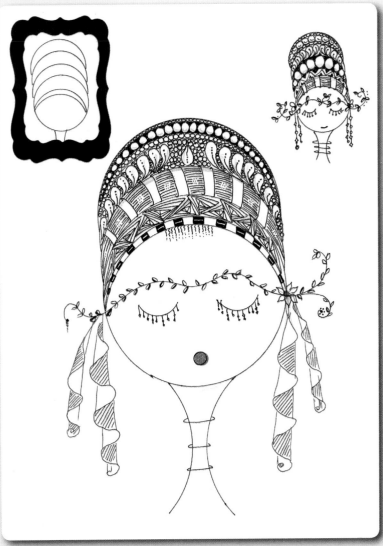

Caribbean lady completed

Here is the finished picture. You can make tiny pictures using a circular template, as shown in the small step out framed in black on the left and the finished small Caribbean lady on the right. You can get very creative with different earrings and head decorations. Make as many bands as you like, and add colour if you prefer.

Decorating boxes

The Zentangle Method can bring a whole new dimension to making cards and boxes. If you have not previously thought of making either, now is your chance to try.

You will need a box-maker for this next exercise, and some card. The box-maker I use is a Groovy score board, which is inexpensive and can be used for scoring both cards and boxes. The card should be 300 gsm (140 lb), although 250 gsm (100 lb) or heavyweight artists' paper would suffice. The size of the card will depend on the size of the box you are making, but for this exercise two A4 sheets of card should be ample.

First, cut the two pieces of card – one for the base and one for the lid. Next, use the box-maker to do the scoring as it does this precisely – one side of the machine is for scoring the base and the other for scoring the slightly larger lid.

If you don't have a box-maker, find a ready-made box and a sheet of card. Decide how you would like to decorate the box – do you want decoration just on the lid, or on the sides as well? Measure how big your pieces of card will need to be to fit the areas you want to decorate. Once you have decided, draw your tangles on the cards, cut them out and stick them to the box.

In the illustration shown I have tangled the lid after doing the scoring, running the patterns down the sides of the lid and leaving some white areas for effect. I cut a triangle out of the corners to help with the folding; there was no need to tangle these because I knew they wouldn't be seen. The next step was to fold in the triangles and stick them to the sides.

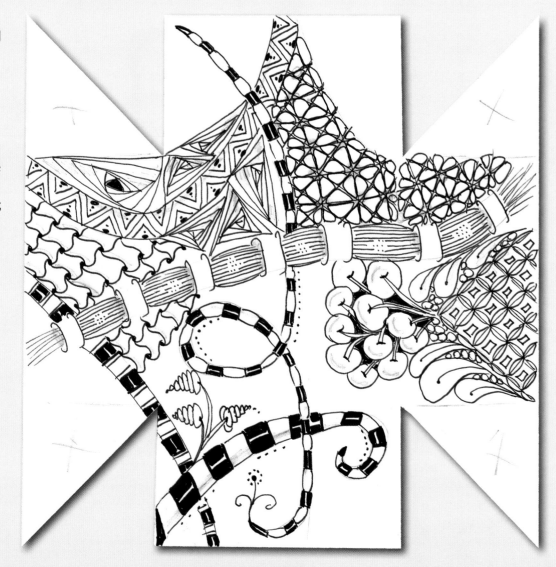

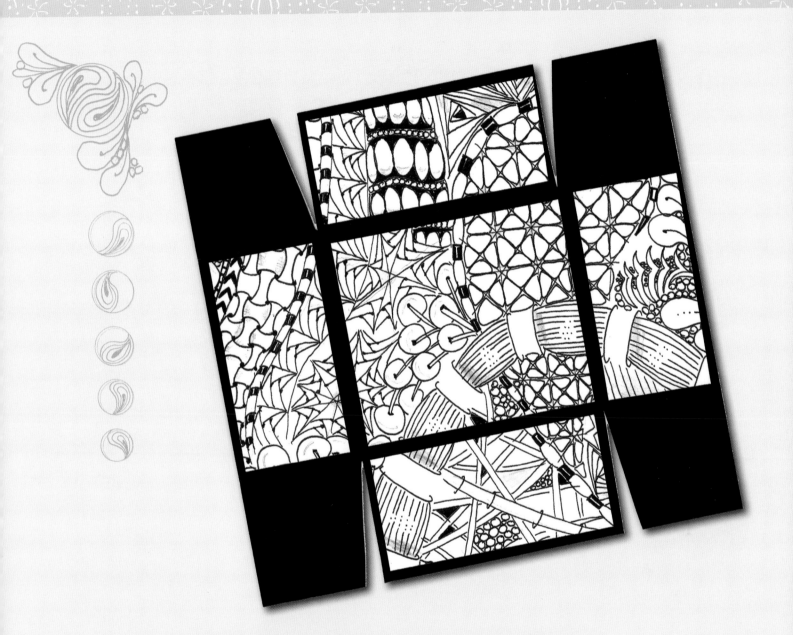

The second box is made with a black lid with pieces of artwork cut to fit the top and four sides. It is a good idea to keep the pieces matching so that the pattern flows over the sides. Make the pieces you cut out a bit smaller than the area you are sticking them on to – this will give the effect of a black border.

Everyone seems to love decorative boxes, so it is worth having a go, either with a box-maker or experimenting with ready-mades.

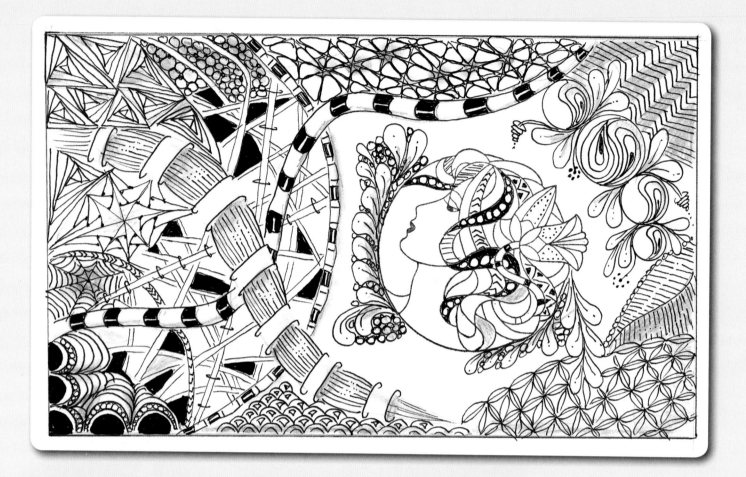

Decorating covers

In no time at all you will undoubtedly accumulate a lot of artwork that you would like to display. I store mine in sketchbooks, which are inexpensive but often contain good-quality artist paper – ideal for tangling directly on to as well as serving as a scrapbook.

I like to personalize my sketchbooks by painting their rather drab (often brown chipboard) covers. For this I use white acrylic paint (which dries very quickly) and then tangle over the top using a Sakura Micron black pen. Rubber stamps can work well, too. Above is one of my favourites – Madeleine by Claritystamp.

Using stencils

I love using stencils, as do my students. You can tangle either inside the stencil shape or around it, leaving the shape blank. Dreamweaver stencils are particularly good to use; they are metal and beautifully made. Lynell Harlow of Dreamweaver kindly sent me some fabulous new designs for use in this book. Among them are the Cowboy Boot and Ginger Jar stencils used to create the projects on pp.30–31. I particularly like the Ginger Jar because it is so versatile.

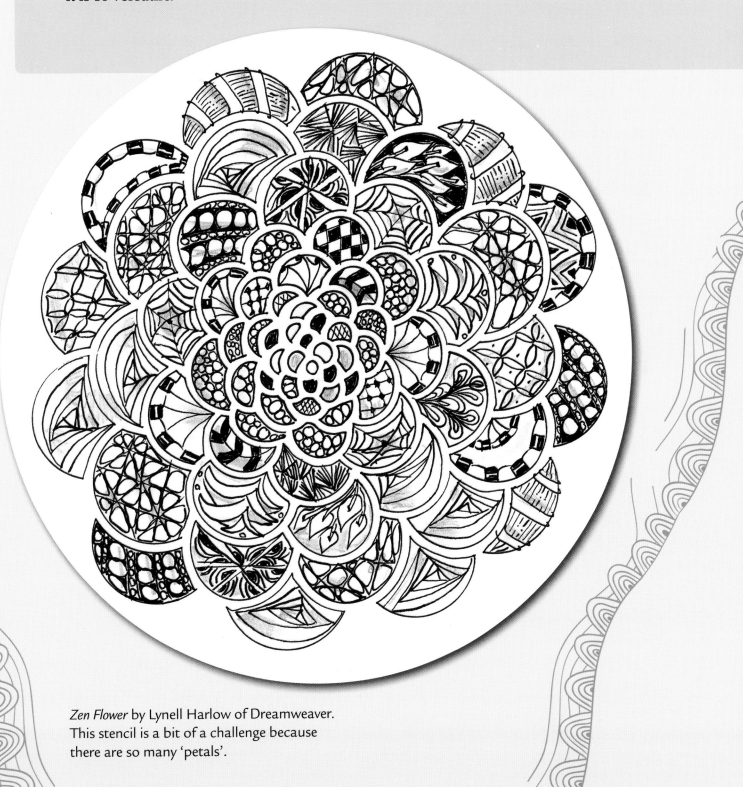

Zen Flower by Lynell Harlow of Dreamweaver.
This stencil is a bit of a challenge because there are so many 'petals'.

Cowboy Boot

The combination of stencils and tangling offers many possibilities for creating novel greetings cards and gift tags. This cowboy boot is suitable for people of all ages.

1. Holding the stencil firmly against your card, draw the outline inside the stencil with your 01 pen. Then take a pencil and draw a string within the outline.

2. Now tangle inside each of the shapes you have created.

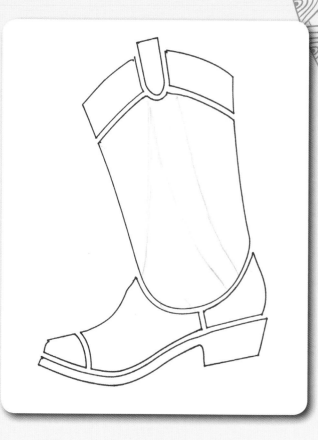

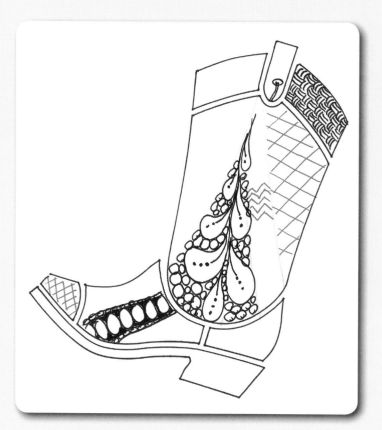

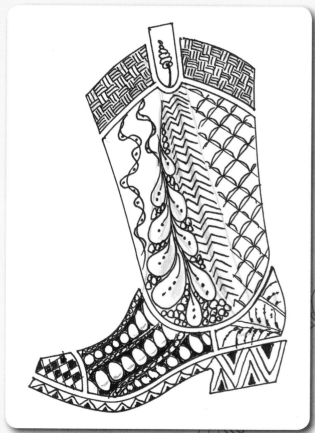

3. Finish the artwork by applying some shading to give your pattern depth.

Ginger Jar

The joy of this very versatile stencil is that it will give you a different effect each time you tangle it.

1. Using the stencil, draw the outline of the jar with your 01 pen.

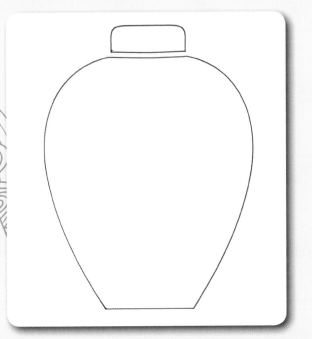

2. Draw a string within the outline.

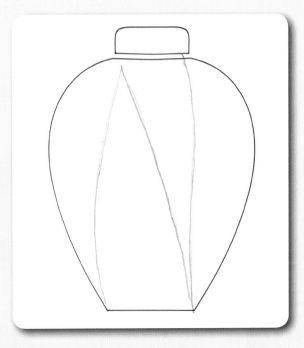

3. Now apply your chosen tangle patterns. I used Verdigogh, Static, N'Zeppel, Flux and, for the lid, Chillon.

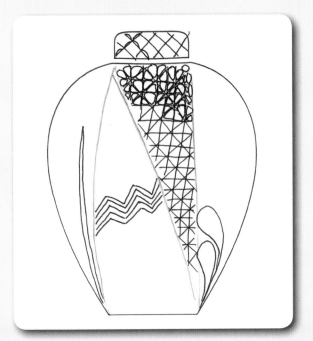

4. Shade the finished tangles

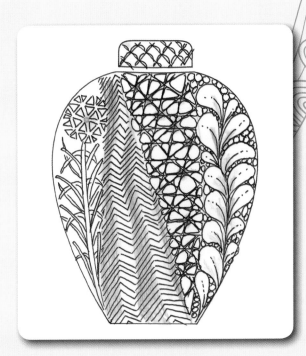

Ideas for cards

This project is for card-makers who own a die-cutting machine. I expect you will already have some nice dies – perhaps a few Nestabilities from Spellbinders or similar.

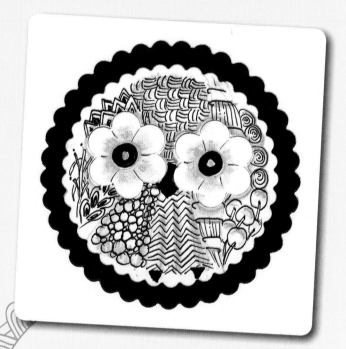

Here I have used the Dreamweaver cat stencil and framed him by mounting him on to black card.

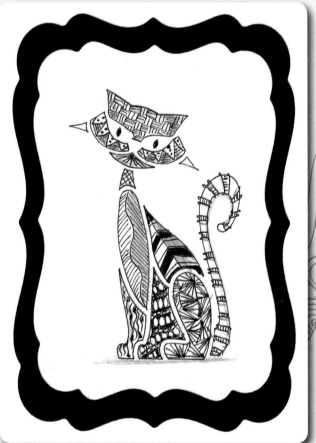

I made this owl by die-cutting two circles, one in white for the artwork and a slightly larger black one for sticking on the first one. I made the eyes with the help of a paper punch and then stuck them on, too. I drew a few lines for strings and then added the following tangles: Tipple, Static, Zander, Poke Root, Keeko, Flux and a little bit of Verdigogh.

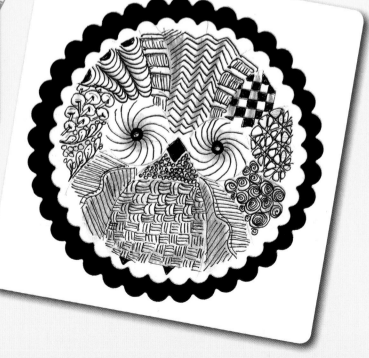

The next example is an owl that I drew from scratch. Start with the eyes, draw strings around them and then fill in with tangles.

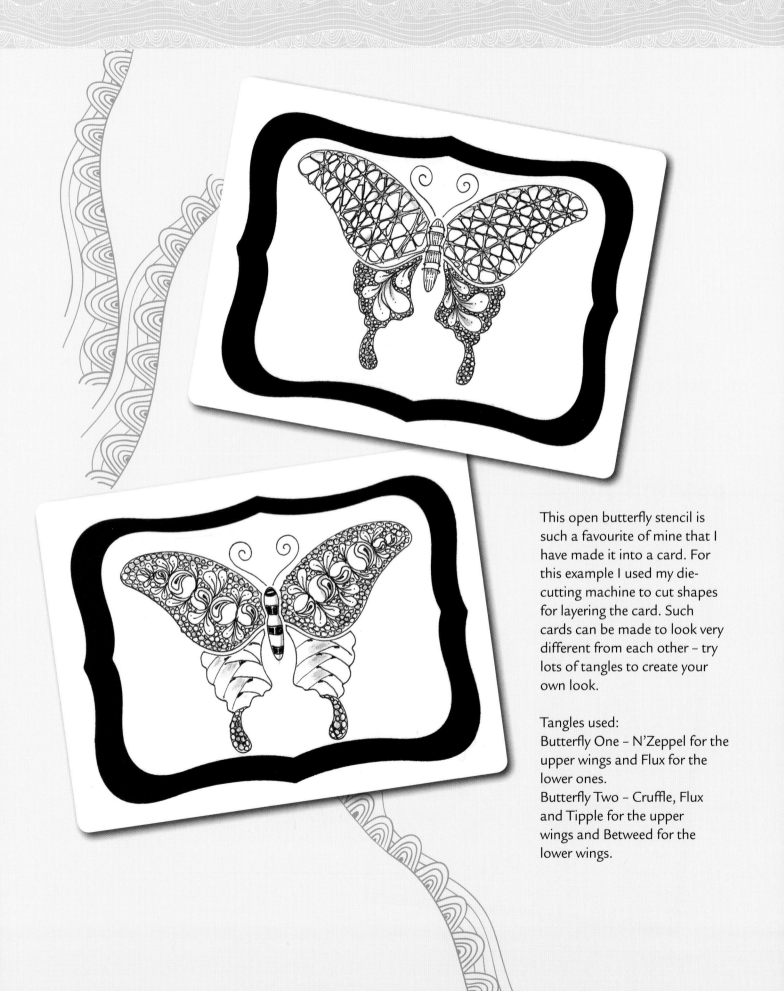

This open butterfly stencil is such a favourite of mine that I have made it into a card. For this example I used my die-cutting machine to cut shapes for layering the card. Such cards can be made to look very different from each other – try lots of tangles to create your own look.

Tangles used:
Butterfly One – N'Zeppel for the upper wings and Flux for the lower ones.
Butterfly Two – Cruffle, Flux and Tipple for the upper wings and Betweed for the lower wings.

A stencil within a stencil

Here we have two examples of using a stencil within a stencil. In the first example I have put a cat inside the Ginger Jar. In the second, a fish seems to be diving inside the jar – that was a very tight squeeze!

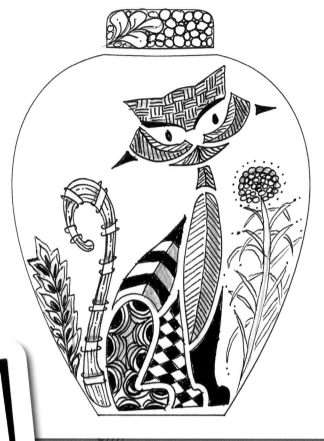

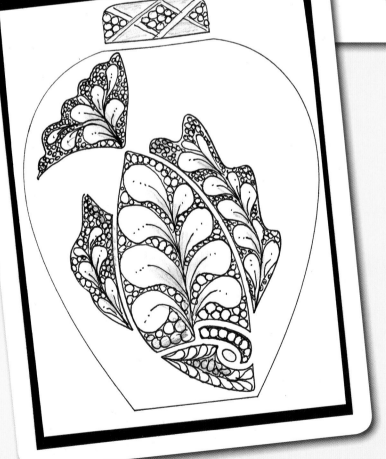

Tangles used:
Ginger Jar One – Keeko, Meer, Braze, Verdigogh, Zander, Ynix, Knightsbridge and Crescent Moon; Ginger Jar Two – Flux.

Stencils – white on black

It is fun to invert the usual black on white and have a go at white on black. This will give your work an entirely different look – compare the two examples of vases shown here.

For working white on black you will need black paper, a Sakura Gelly Roll white pen and a white charcoal pencil for the string and the shading. The Gelly Roll pen is very fluid and so has an entirely different feel to the usual Sakura Micron.

You can also use the white Gelly Roll pen for adding highlights – notice the black stripes on the handles in the second example shown.

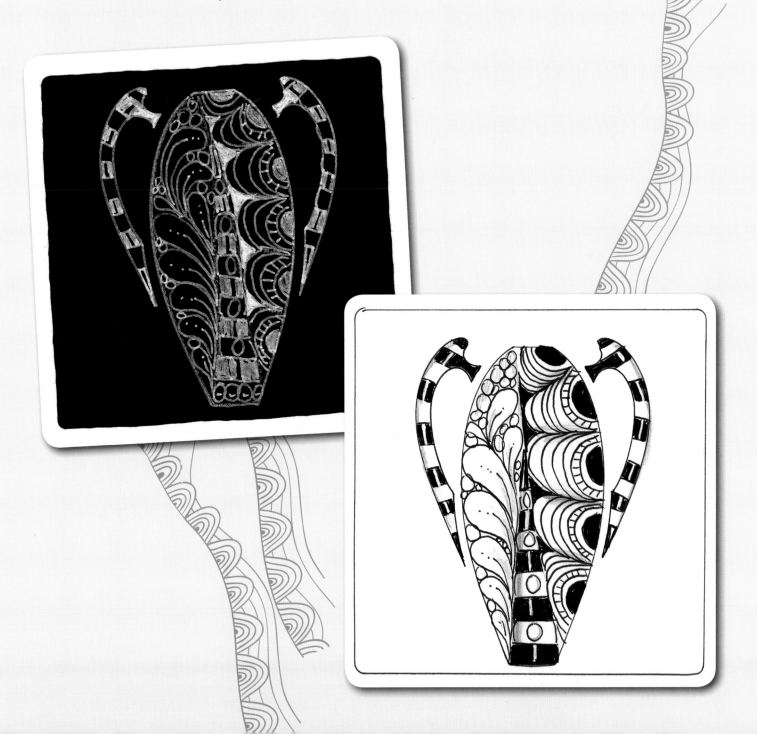

Kala Dala Stencils

I have used Julie Evans' lovely stencils for some time as they are very satisfying to work with and each time they turn out differently. Julie sent me a set of 11.5 cm (4½ in) stencils to go with the 9 cm (3½ in) ones that I already had. There are five in a pack. They are not metal so some care is needed to hold them steady while drawing the outline, but once you have mastered this you are away. You can tangle the whole of the stencil or just part of it, as shown.

Tangles used:
Flux and
Paradox.

Tangles used:
N'Zeppel and
Paradox.

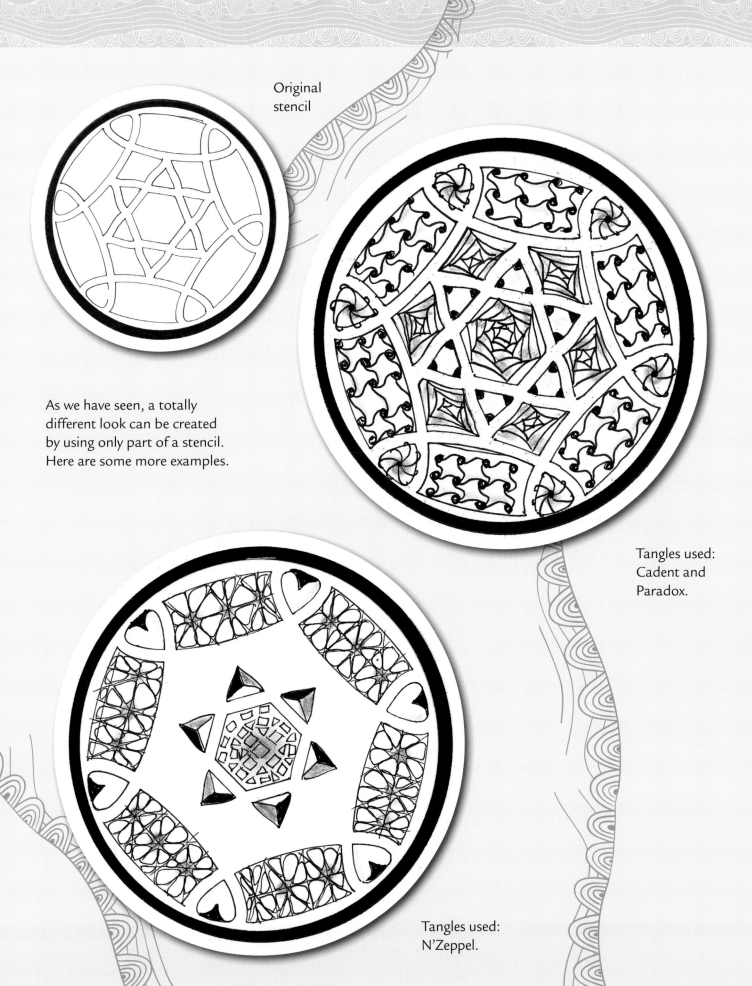

Original
stencil

As we have seen, a totally
different look can be created
by using only part of a stencil.
Here are some more examples.

Tangles used:
Cadent and
Paradox.

Tangles used:
N'Zeppel.

Kala Dala large demo stencil

This is part of a large demo stencil. The whole of it would not fit on the page but part of it makes an attractive design. Adding some colour enhances its effect.

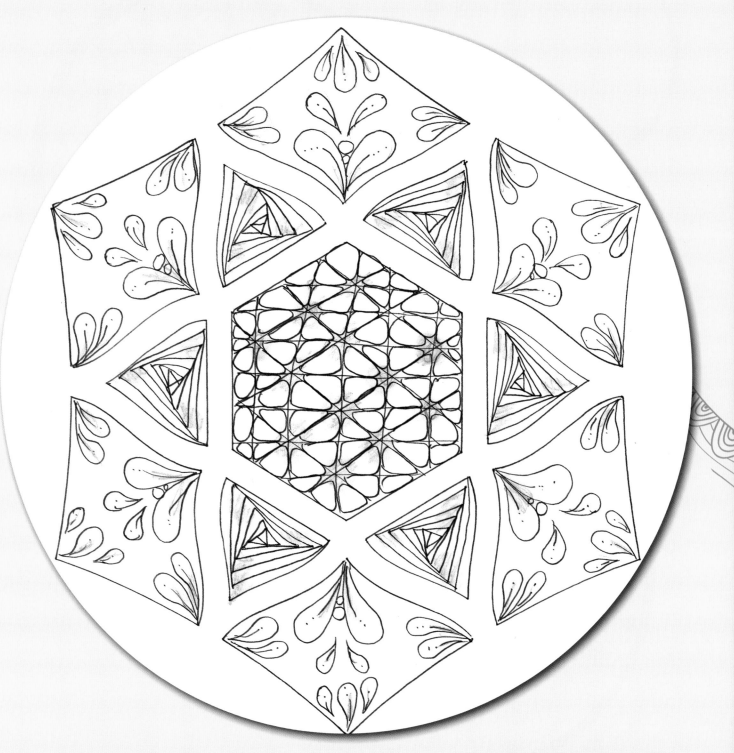

Tangles used: Paradox and Flux; N'Zeppel for the centre.

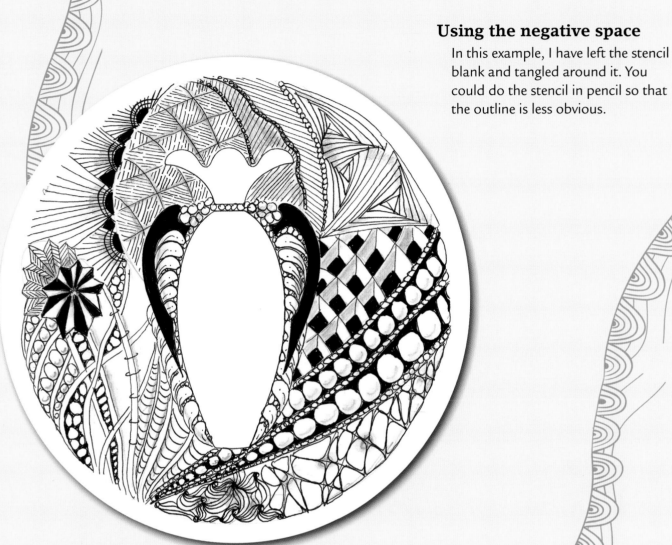

Using the negative space

In this example, I have left the stencil blank and tangled around it. You could do the stencil in pencil so that the outline is less obvious.

This image was created by drawing around a letter and then leaving it as a negative space. I used a range of standard tangles to set off the letter.

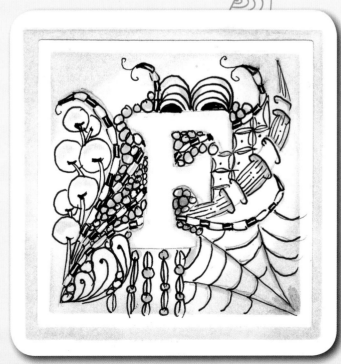

Zendalas

Zendalas are like mandalas but with a Zentangle twist. They can be created in several ways from simply tracing around a circle (a CD, protractor or a compass) to using stencils.

Here I used my protractor – which is transparent – to draw the outline and the strings. While I was tangling I decided to have Btl Joos and Zander running through it, so I added two lines (marked with dashes in the illustration). The original strings were just guidelines, so I was able to make amendments to my design as necessary.

Tangles used:
Footlites, Poke Root,
N'Zeppel, Paradox, Zander,
Knightsbridge, Onamato, W2
and Tripoli.

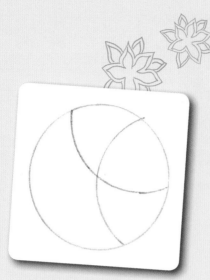

You can work with a compass to create beautiful Zendalas. This is a lot of fun. Flower-like shapes are the simplest. Let's make some.

1. Draw a circle to the diameter of your choice.

2. Put the point of the compass anywhere on the outside circle then draw a part-circle from one point to another on the circle; if you are using a cheap compass without screw fixings, take care not to change the diameter setting as you perform this manoeuvre.

3. Starting on one of the points of the circle, draw another circle from edge to edge. Go around the circle in one direction until you have formed 'petals' within the circle.

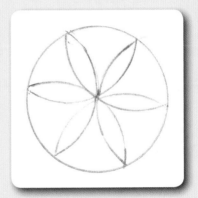

4. This is how your drawing will look when you have gone all the way round the circle.

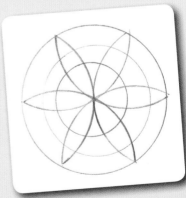

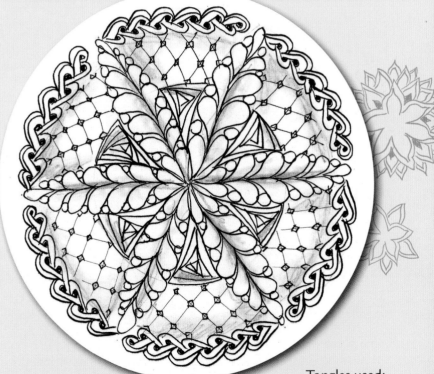

Tangles used: Heartrope, Flux, Florz and Paradox.

5. Decide whether you want to divide it up further with inner circles to make more spaces to tangle. In my illustration I have added two circles, but in my finished Zendala I added only one.

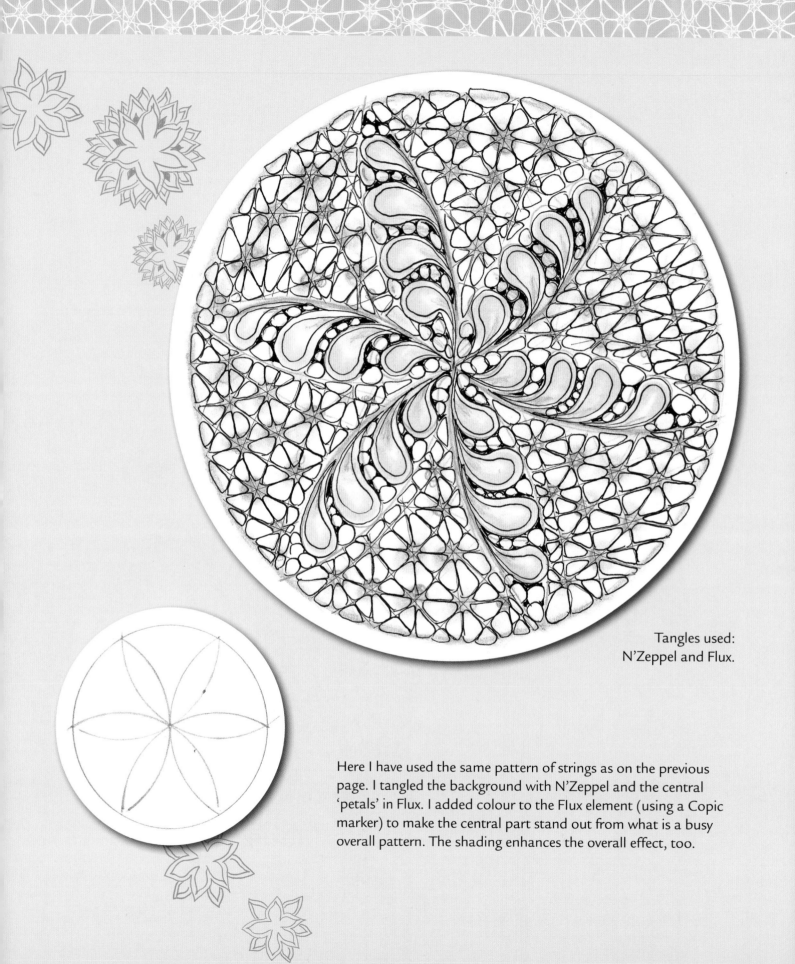

Tangles used:
N'Zeppel and Flux.

Here I have used the same pattern of strings as on the previous page. I tangled the background with N'Zeppel and the central 'petals' in Flux. I added colour to the Flux element (using a Copic marker) to make the central part stand out from what is a busy overall pattern. The shading enhances the overall effect, too.

Pre-strung Zendalas

Pre-strung Zendala tiles with the string already imprinted are available from Rick and Maria's website (www.zentangle.com).

For this example I have used a range of tangles: Florz, Flux, Poke Root, Zander, Paradox, Hollibaugh, Heartrope and Tipple.

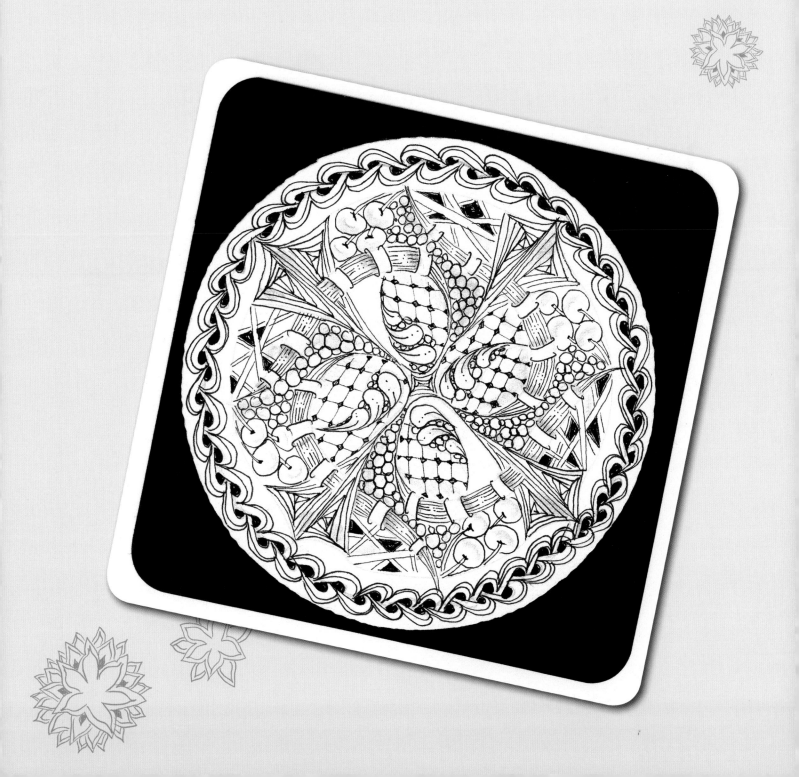

Shapes

I am always on the lookout for things that I can use creatively. You can trace around various shapes, draw a string within them and choose some tangles. I found some chipboard shapes of butterflies at a craft fair. The right half of the butterflies shows the tangles, and the other half the strings that I used.

Small Butterfly tangles:
Barberpole for the body and Evoke, Bales variation and Pinch for the wings.

Large Butterfly tangles:
Zander for the body and Hollibaugh variation, Crescent Moon in the middle of Hollibaugh, Static and Jetties.

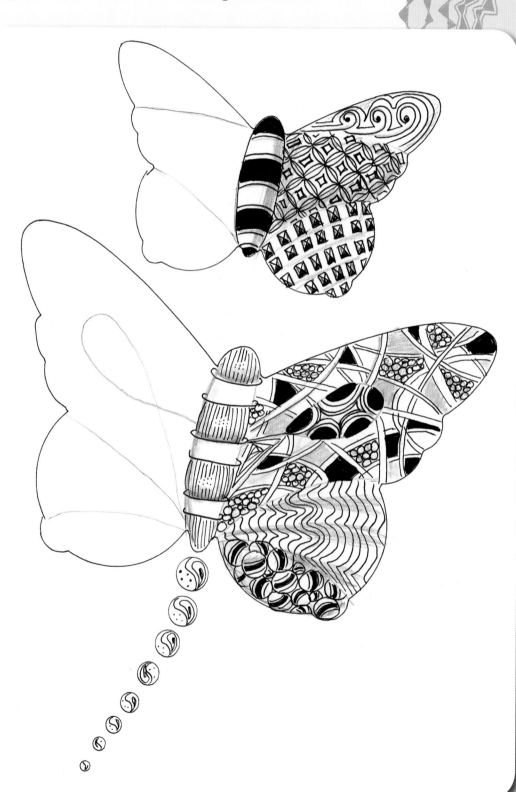

This elephant was traced from a card that a friend passed on to me. If you look through books or magazine you will find all sorts of images for inspiration. I used Cubine for his trunk, N'Zeppel for his stomach and Crescent Moon for a saddle. For the ball, I used the tangles Tipple, Knightsbridge, Meer and Floos.

Letters and numbers

Zentangle is invaluable for creating decorative numbers and letters. There are all sorts of stencils you can buy or you could trace from books. The letters shown are outlined in pen, but you could use pencil for a less uniform look.

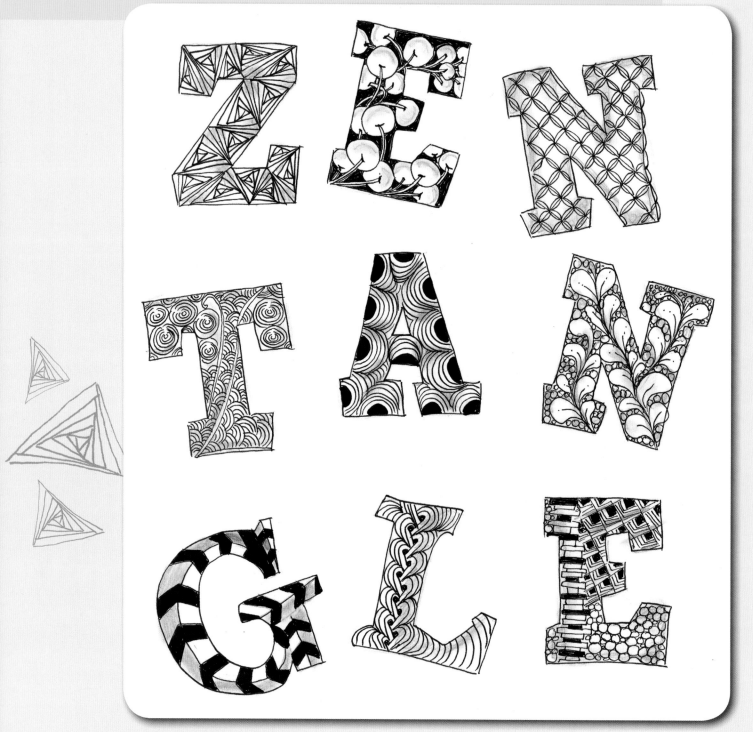

Tangles used:
 Z – Paradox, E – Poke Root, N – Bales, T – Printemps & Shattuck, A – Crescent
Moon, N – Flux, G – Braze, L – Heartrope, E – BB, Tipple & Flukes.

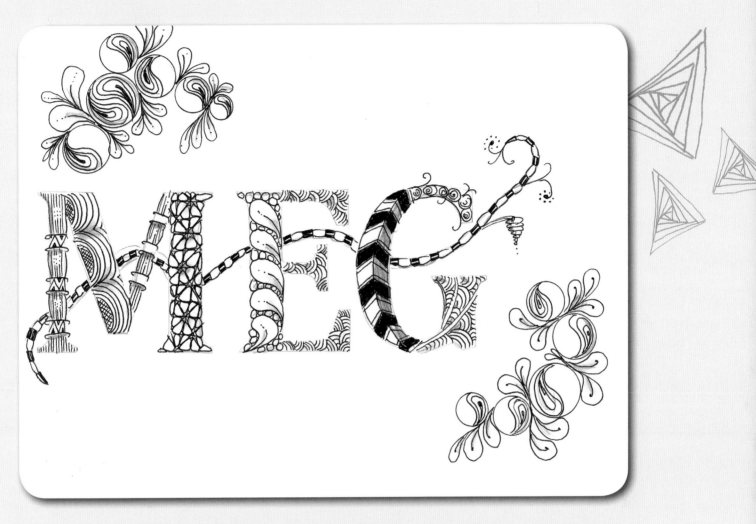

Knowing how to tangle letters and numbers is very helpful if you like making your own greetings cards. I made a card for my granddaughter Meg's birthday this year. Because her name is short I was able to put a lot of work into adding enhancements to the letters. The illustration shown here is a simplified version.

Tangles used:
Zander, Crescent Moon variation, N'Zeppel, Flux and Braze. Decoration: Cruffle with Flux.

Another way of using letters for gift purposes is to leave the letters blank and tangle round them; I used Crescent Moon for the letter S, and for the letter Z Hollibaugh partly filled in with black and with Tipple.

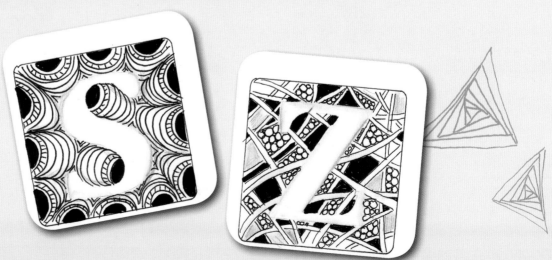

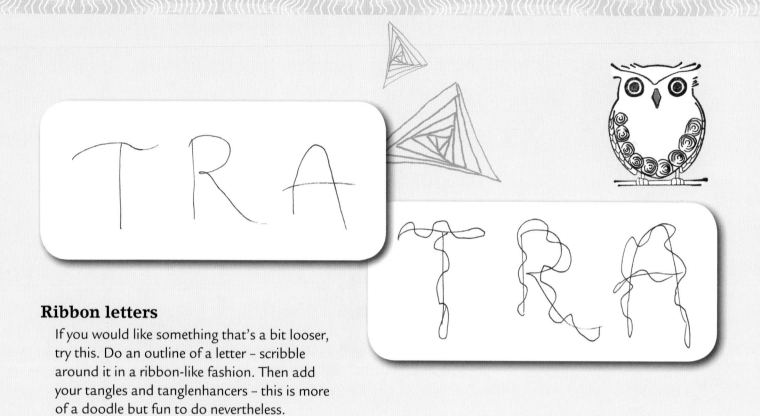

Ribbon letters

If you would like something that's a bit looser, try this. Do an outline of a letter – scribble around it in a ribbon-like fashion. Then add your tangles and tanglenhancers – this is more of a doodle but fun to do nevertheless.

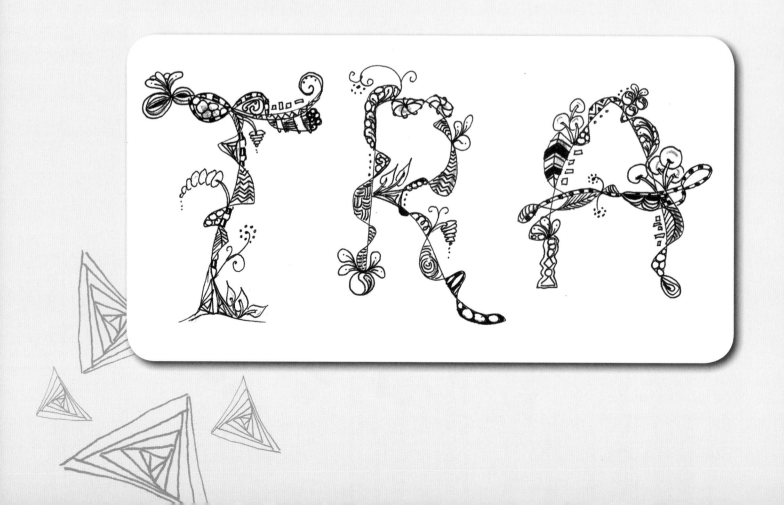

Using numbers

Number stencils are useful for birthday cards or putting in journals. You can find inexpensive versions online or in stationery shops. You just push out the numbers and you are left with the stencil; if you save the numbers they can be used for filling in the circles inside the numbers 0, 6, 8 and 9 and the triangle in the number 4, though this can easily be done freehand.

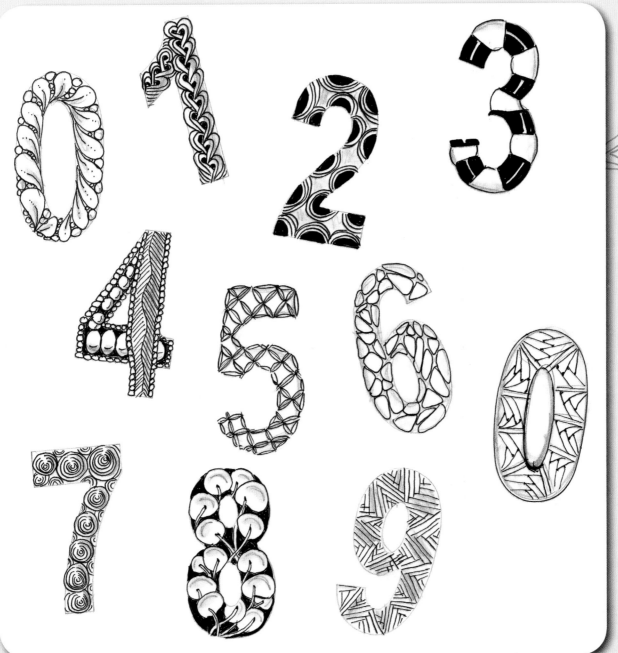

Try out all sorts of tangles for different effects. The numbers shown here were done with a pencil outline, except for the second zero which is outlined in pen.

Tangles used:
0 – Flux, 1 – Heartrope, 2 – Crescent Moon, 3 – Btl Joos, 4 – Onamato & Meer, 5 – Bales, 6 – N'Zeppel random, 0 – Betweed, 7 – Printemps, 8 – Poke Root and 9 – Hibred variation.

Rubber stamping

Being a card-maker, I have a wide selection of rubber stamps and have found some of these to be good for tangling.

One of my favourite artists is Barbara Gray, creator of Claritystamps. Barbara was the first to make clear stamps – they are easy to use and, of course, see-through. She includes tangling in her demonstrations on Create and Craft TV and has some lovely stamps that can be used to tangle.

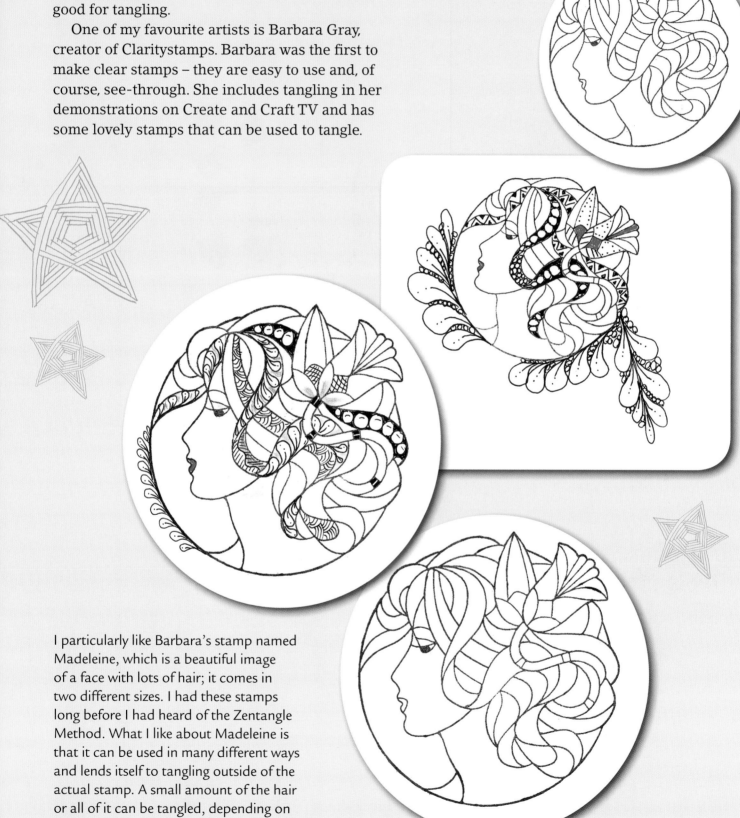

I particularly like Barbara's stamp named Madeleine, which is a beautiful image of a face with lots of hair; it comes in two different sizes. I had these stamps long before I had heard of the Zentangle Method. What I like about Madeleine is that it can be used in many different ways and lends itself to tangling outside of the actual stamp. A small amount of the hair or all of it can be tangled, depending on the look you want to create.

The other Claritystamps I have used here are, clockwise from right: Moon Fairy, Sketched Shoe, an easel and a handbag.

When using stamps for tangling, it is important to use a dye-based ink pad to ink up your stamp so that the ink will not bleed into your pen work.

Another of my favourite artists in the stamping world is Françoise Read, who designs for Woodware Stamps. Some of her stamps are perfect for tangling. One of my favourites is her wellington boot.

The stamp is of a single boot but you can make two quite simply.

First, stamp the boot in black ink onto a piece of white card. Then stamp the boot again onto a large Post-it note, making sure that part of the stamping is on the sticky edge. Next, cut out the stamping on the Post-it note and stick it directly over the first stamping on the white card. Ink up the stamp again and stamp it to the side of the first boot and partially over the post-it note. When you remove the Post-it note – which can be saved to use again – you have magically placed one boot behind the other.

Now they are ready to tangle – you could use the same tangle for both boots or use different tangles on each, as I have done. You could then colour them in or leave parts of them blank.

Tangles used: Bales, Hollibaugh, Static, Flux, Zander and Betweed.

Have fun!

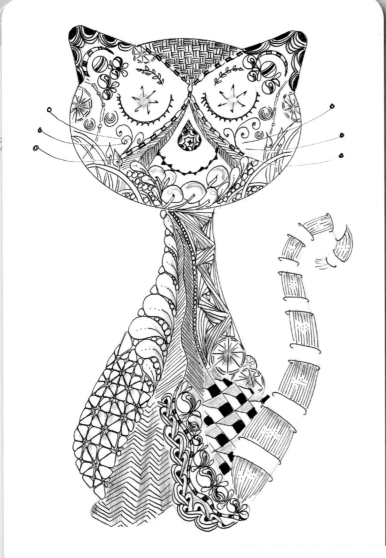

To tangle this cat, I traced around the lid from my cat's box of treats. I then drew a simple body to go with it – it is purposely not in proportion. I have drawn strings inside the cat outline and then filled them with a wide range of tangles. Draw the string any way you like, and choose the tangles you want to put inside.

A note from Françoise Read

'My first real encounter with tangling was a workshop at CHA with Joanne Fink. She really inspired me. I love the one-off look and, of course, the process. It's so easy to do and very calming!'

Here I have made a picture with another of Françoise Read's stamps. The tangles Cubine and Shattuck were used for the fish on the left. For the other one I used Betweed and Nipa. It can be fun to create a scene around your stamp; my seascape was made from Verdigogh, Festune, Btl Joos, Cruffle, Poke Root, Cyme and Flux. Paradox and Meer were used for the borders.

Kids' time

It is very calming for children to have time set aside to tangle, and it improves their concentration and handwriting as well.

Children are wonderful to teach because they are naturally creative and have their own ideas about what they want to do and how to go about it. They love using stencils and rubber stamps. Cheap stencils are widely available, so there's plenty of scope.

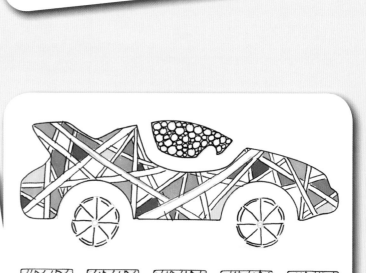

Simple stencils were used to create these pictures. You could trace them off the page to make your own versions. Copic Markers were used for the aeroplane; these have a soft brush tip which makes it easy to blend toning colours. I used Hollibaugh but without putting in too many lines so that I could fill in using other tangles – N'Zeppel, Tipple and Crescent Moon.

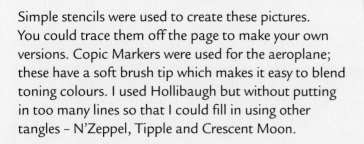

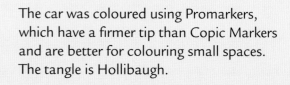

The car was coloured using Promarkers, which have a firmer tip than Copic Markers and are better for colouring small spaces. The tangle is Hollibaugh.

Making cards and bookmarks

Inkadinkado's Hooty Owl is very popular with both adults and children and is well worth buying. The children love giving the owl different 'clothes', and I have shown him here in various guises.

Here's how to make an owl card.

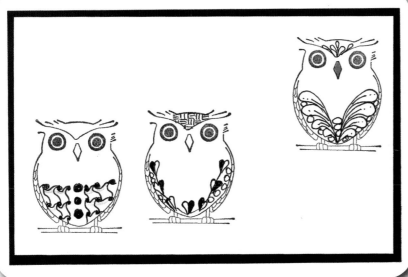

Using a black inkpad, stamp three owls on a piece of white card. Decorate your owls with your choice of tangles. Then measure the piece of white card that you have used and cut out a piece of black card a little bigger than the white card. Stick the white card with the three owls onto the black card. This gives you a frame for your artwork which can be stuck onto a blank card; packs of card blanks and envelopes can be bought quite inexpensively.

Make a bookmark by sticking the owl on black card. You could add a little colour to the beak and tangle the black card (using a Sakura Gelly Roll white pen), as I have done here. I also added some shading with a white charcoal pencil. Gelly Roll pens are fun to use and have an entirely different feel because they are very fluid.

Owl project

Open stamps are brilliant for tangling. I was sent this lovely example featuring an owl by Françoise Read of Woodware Stamps.

I used the following tangles: Keeko, Purk, Florz, Meer, and Mooka for his wings.

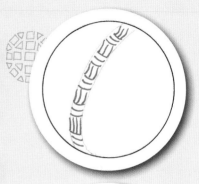

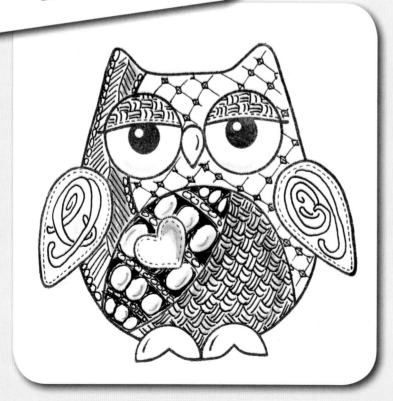

Owl stamp

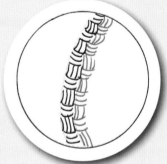

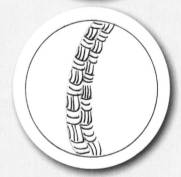

Keeko tangle for the owl body

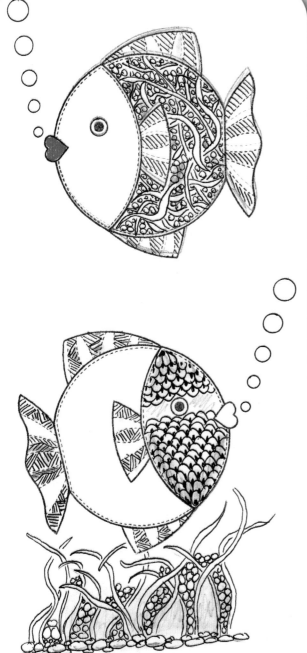

Fish projects

Here are two fish projects, the first using a stamp by Françoise Read, and Mysteria and Tagh tangles.

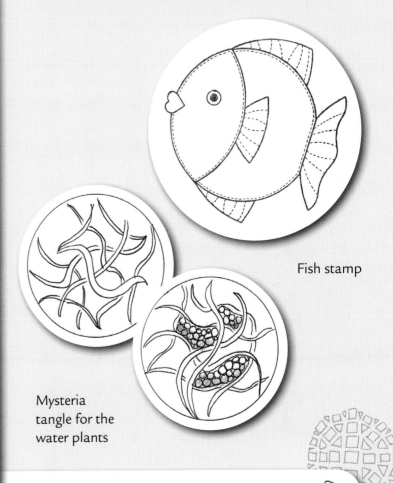

Fish stamp

Mysteria tangle for the water plants

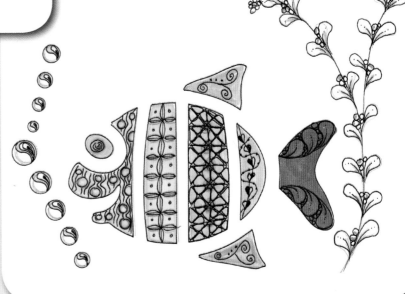

The second example was created using a very simple stencil. This could be traced from the book for you to replicate. I used Copic Markers for the colouring, and then did the tangles on top. The tangles used are Nipa, Bales, N'Zeppel, Heartrope, Flux and Cruffle.

Making Christmas baubles

A single bauble would make a good Christmas card. I haven't seen a holly tangle anywhere, probably because it is easy and doesn't really need a step-out though I have done a small one here. Holly is very pretty, and lovely as a Christmas ornament. You could use some sparkly Sakura Gelly Roll pens – especially for the holly berries. Get the children to make their own decorations for the tree. Draw a shape, fold in half and cut out. You can then draw around it – both sides are equal if you have folded it in half before cutting. You might even find some stencils with various suitable shapes; Dreamweaver produce a lovely Christmas ornament.

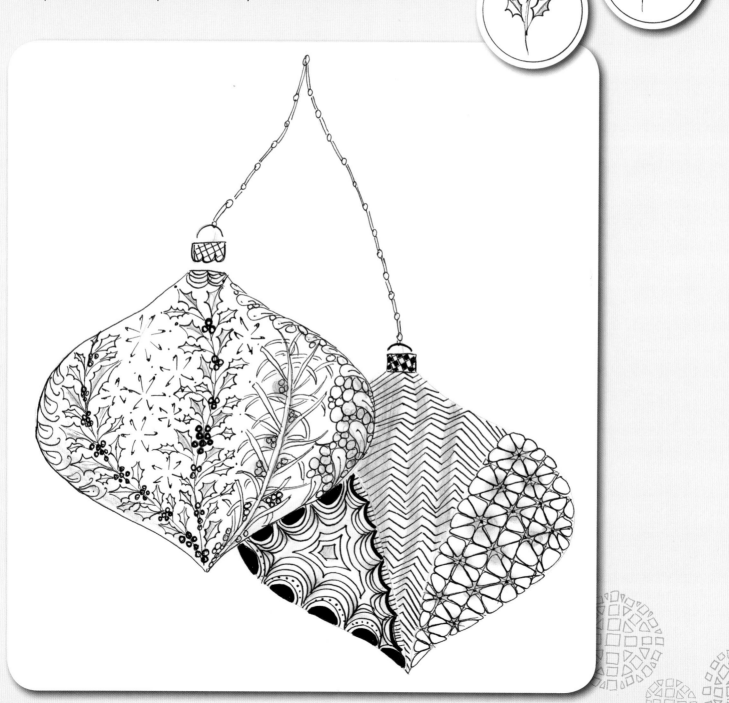

Photo frame project

A photo frame is fun for children to create when they have something special to put in it. This frame was done by one of my many granddaughters, Steffi, aged seven, to frame a photo of her first tennis tournament win. She loves to do Lilah Beans, created by Sandy Steen Bartholomew's daughter Lilah when she was very young. Note all the different expressions Steffi has done on her Lilah Beans, without any prompting from me. She decided to do a giant Lilah Bean to add to the effect!

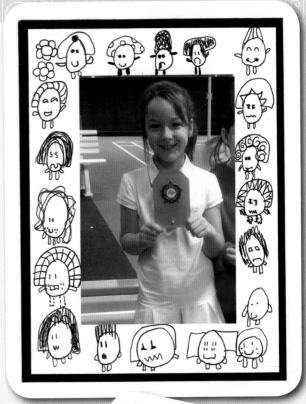

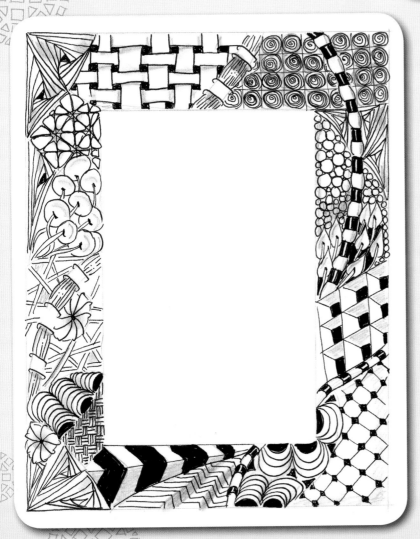

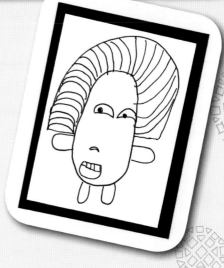

My photo frame This is my grown-up version of a photo frame. Simply draw a border around your photo and then draw a string in the border and fill in with tangles.

Tangles used, in clockwise direction: Paradox, W2, Zander, Tortuca, Btl Joos, Tipple, Poke Leaf, Cubine, Florz, Crescent Moon, Static, Braze, Keeko, Hollibaugh, Festune, Poke Root and N'Zeppel.

Drawing people

Drawing hair is a fun project for children.

In the first example I drew the face and then added a range of tangles for the hair. She looks a bit scary as I am not an artist, but then I think kids would love this, and they might even want to make up a story about her.

Any tangles can be used. The ones shown are Zander, Btl Joos and Heartrope. I die-cut the image and stuck it on to some black card, also die-cut.

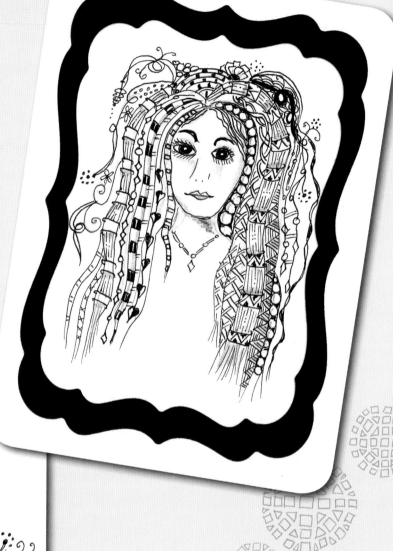

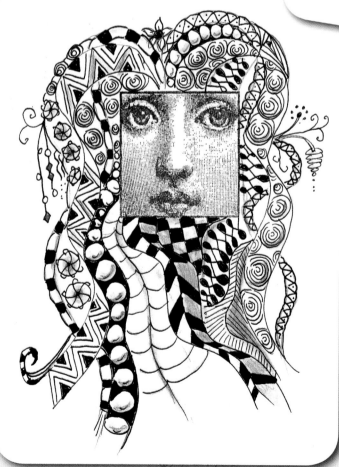

A rubber stamp could also be used. I've had this one (Square Face Frame by Hampton Art Stamps) in my cardmaking store for some time. I first saw it in a book by Suzanne McNeill and am pleased I found an opportunity to use it. This particular stamp makes for a funkier look and offers scope for doing a lot of tangles around it. I have used Braze, Printemps, Btl Joos, Knightsbridge and Festune, plus a few zig-zag patterns.

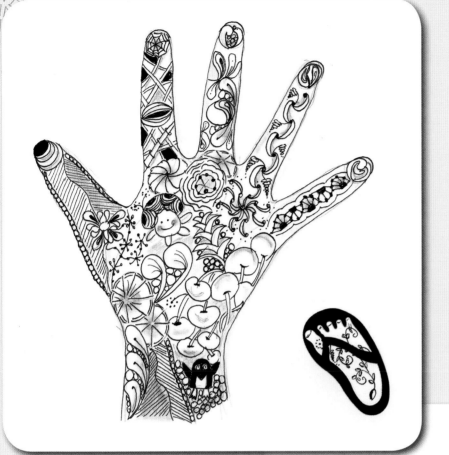

Hands and feet

Hands and feet are perfect for children to trace around and then tangle. Simply show them how to draw around their hand or foot and let them tangle it. My granddaughter Pippa lent me her hand to draw around.

Tanglefolk

The wonderful tanglefolk, created by Billie Lauder, can be seen on a YouTube clip called Zentangle Marketing Retreat. Be sure to watch this, because it features Suzanne McNeill and some of her CZT friends doing all sorts of projects. Billie also appears on the video. She makes creating these characters look so easy. The outline is done in one continuous movement, starting at the head. I used N'Zeppel for the main body.

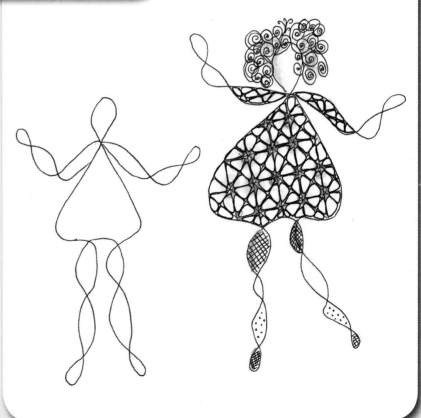

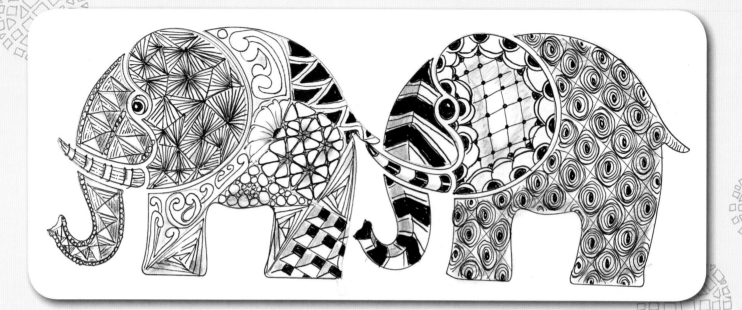

Animal projects

Children love to do all sorts of elephants. This stencil is a great one to use. Place the elephants either tusk to tail or tusk to tusk; if you are ambitious, you could put two more on top of these two or even add a border. It's easy to create a reverse image with a stencil – you simply turn the stencil over.

The pig is created with a Woodware stamp and coloured with a Copic Marker.

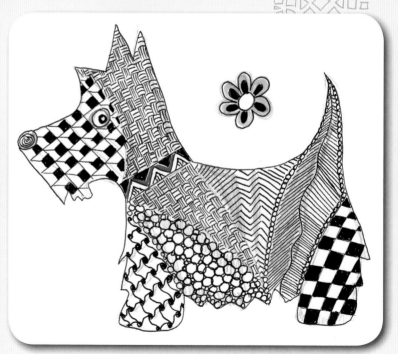

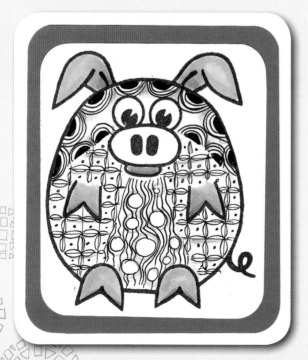

An easy and economical way of creating images to tangle is to find a picture and trace around it on a piece of card, as I did with this dog. I then divided it up with strings and chose some tangles to use. I added a tiny bit of colour with a red Sakura Micron pen.

Directory of Tangles

In this section you will find step outs of many of the tangles included in the book, together with examples of how they might be used. I hope my illustrations will give you some ideas and encourage you to develop your own tangling skills. My selection is just a taster. If you want to find more tangles, go to www.zentangle.com and www.tanglepatterns.com where you will find a wealth of examples to choose from.

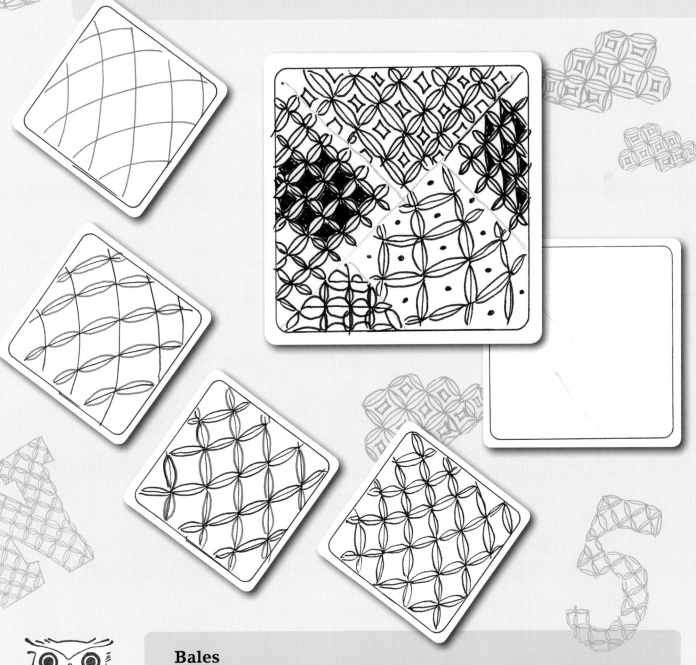

Bales

(original by Rick Roberts and Maria Thomas)

This is probably the easiest of the grid patterns. There are many possible variations, from putting dots in the middle to something more elaborate.

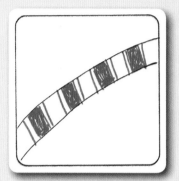

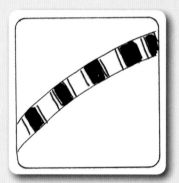

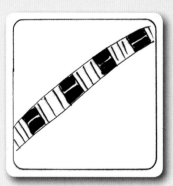

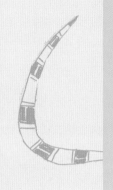

Barberpole
(Suzanne McNeill CZT)

Suzanne is very well known in the Zentangle world and regularly demonstrates various tangles and projects on YouTube. This tangle featured in Suzanne's book *Zentangle 3*. It is useful for running through your Zentangle Inspired Art, as illustrated.

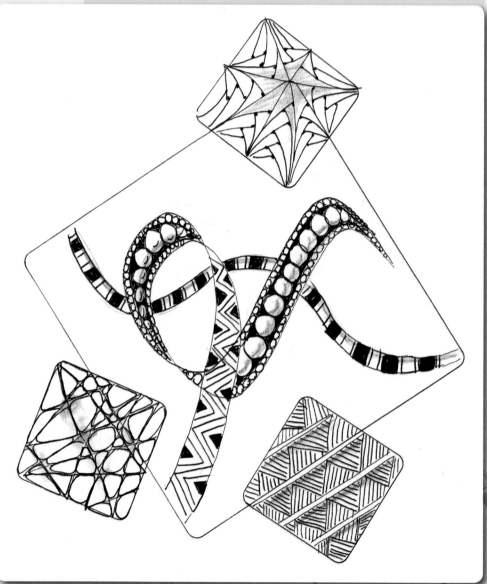

Tangles used:
Betweed, N'Zeppel Random,
Onamato and Shattuck.

BB

(original by Rick Roberts and Maria Thomas)
I have used TanglePatterns String No. 18 for this tangle, with BB running through the middle.

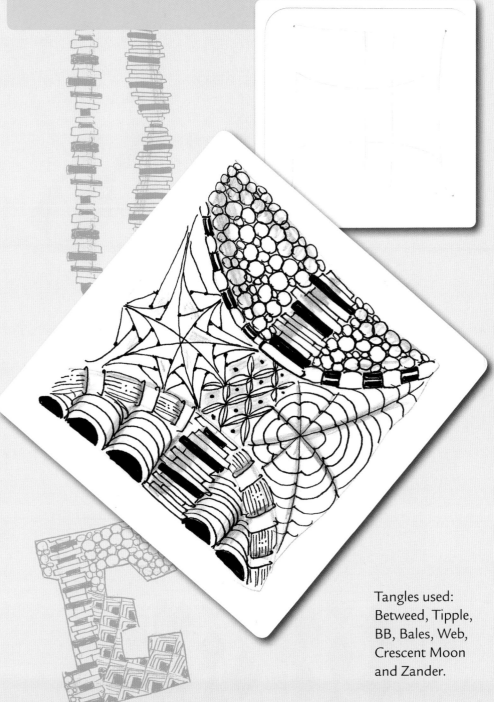

Tangles used:
Betweed, Tipple,
BB, Bales, Web,
Crescent Moon
and Zander.

Beeline

(original by Rick Roberts and Maria Thomas)

This tangle needs a little care to get it going. Using a Sakura Graphic 1 pen makes it easier to fill in the black squares. Shading is very important. Other tangles used here are Bales, Betweed and Flux.

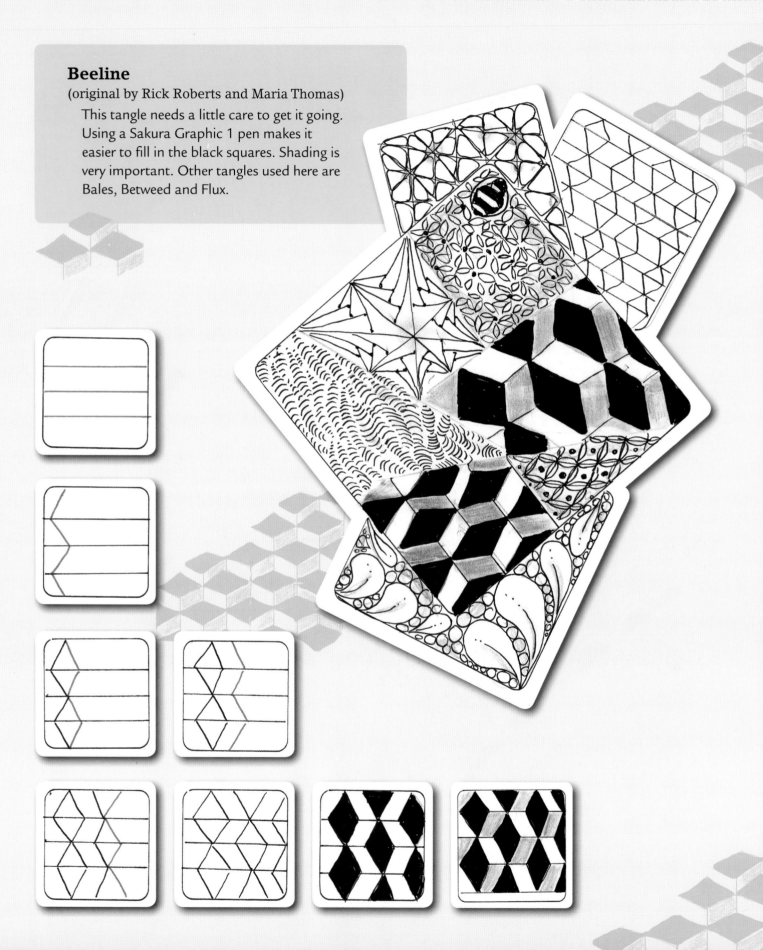

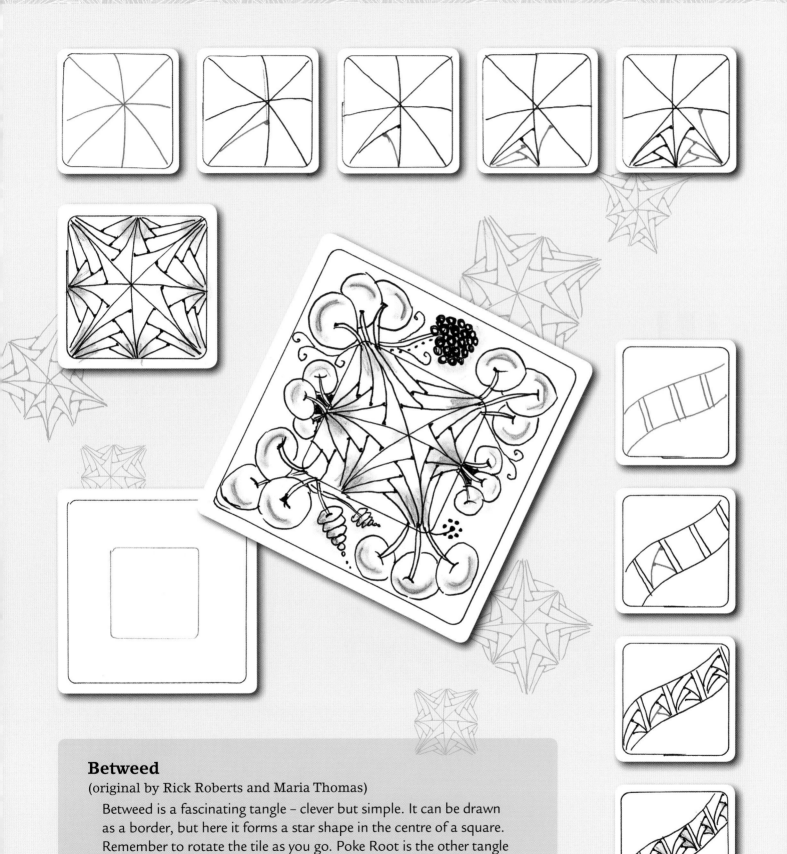

Betweed

(original by Rick Roberts and Maria Thomas)

Betweed is a fascinating tangle – clever but simple. It can be drawn as a border, but here it forms a star shape in the centre of a square. Remember to rotate the tile as you go. Poke Root is the other tangle used here.

Braze

(original by Rick Roberts and Maria Thomas)

The effect of this tangle is all down to the shading.

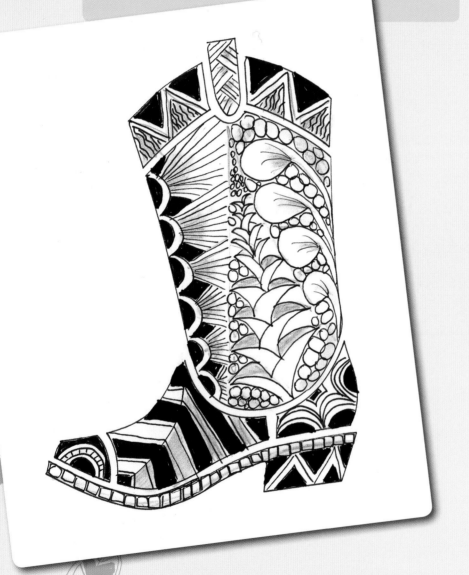

Tangles used:
Knase, Dooleedo (Ksenija Vojisavljevic),
Flux variation, Footlites (Carol Ohl),
Crescent Moon.

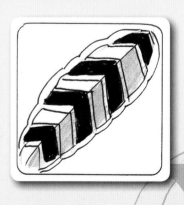

Btl Joos
(Sandy Steen Bartholomew CZT)

Sandy is a talented artist and author from New Hampshire who has been inspirational in the Zentangle community. I love her Btl Joos tangle, which I first came across in her book *Totally Tangled*. It's so perfect and simple to do. Here I have used it with Florz, N'Zeppel and Dooleedo.

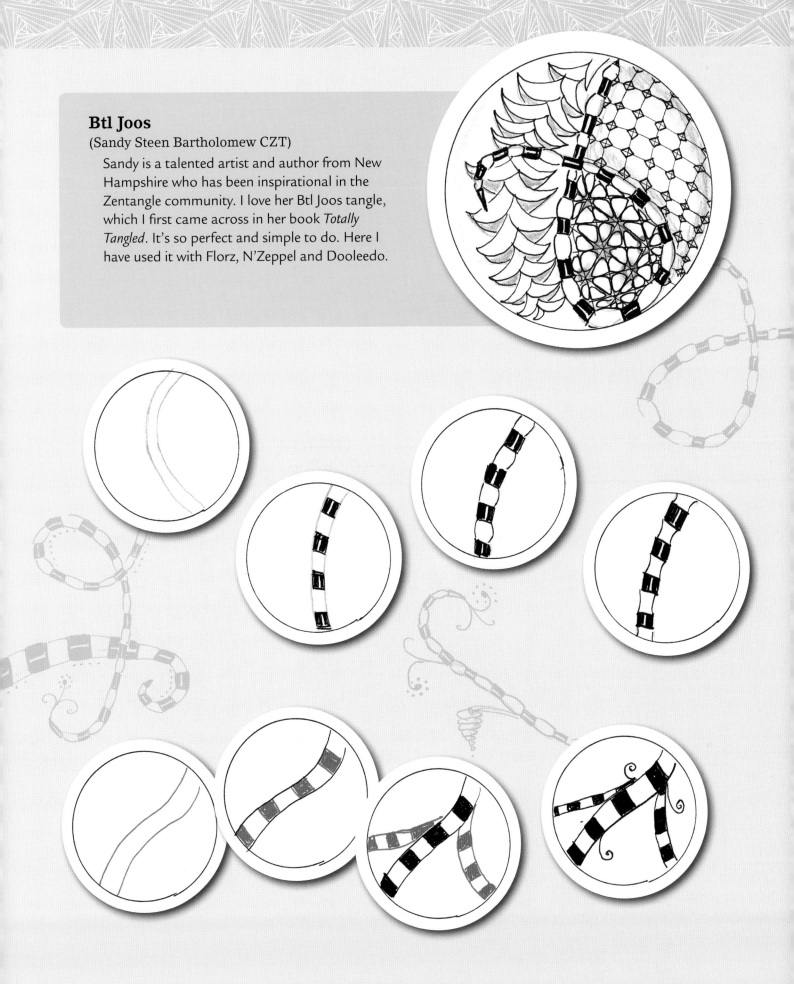

Cadent

(original by Rick Roberts and Maria Thomas)

To make the string for this tile I used my squares template to create square shapes overlapping the first square. This tangle is really created with just an S shape going from the top circle to one below and so on, and then doing the same thing in the other direction after rotating your tile 90 degrees. It gives a roof-tile appearance.

Tangles used:
Keeko, Knightsbridge,W2,
N'Zeppel, Cadent,
Crescent Moon variation,
Flux and Printemps.

→ Rotate 90°

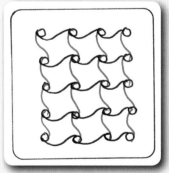

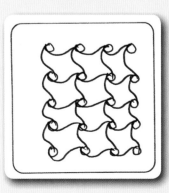

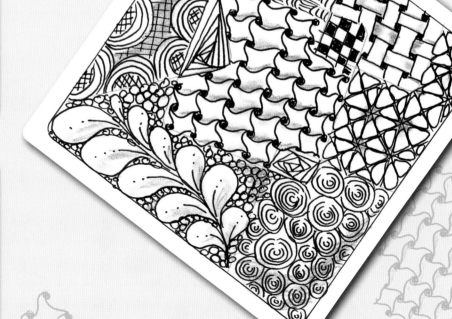

Chaingling
(original by Rick Roberts and Maria Thomas)

Be warned, this tangle really does take a bit of practice to get it right – Rick and Maria make it look easy!

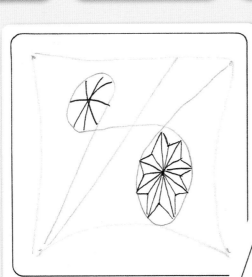

Tangles used:
Joy, Chaingling, Floo, Paradox, Web, Jetties, Tipple, Static and Gneiss.

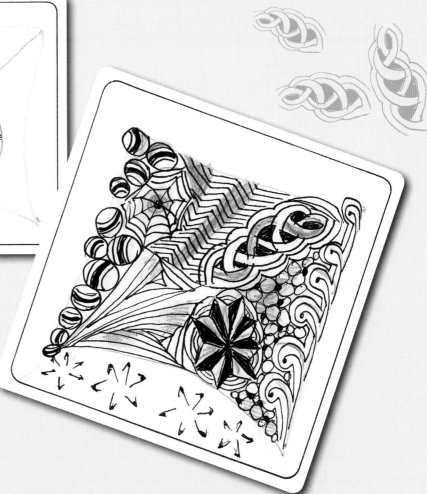

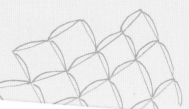

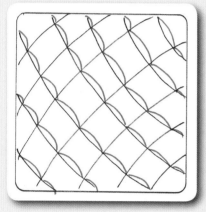

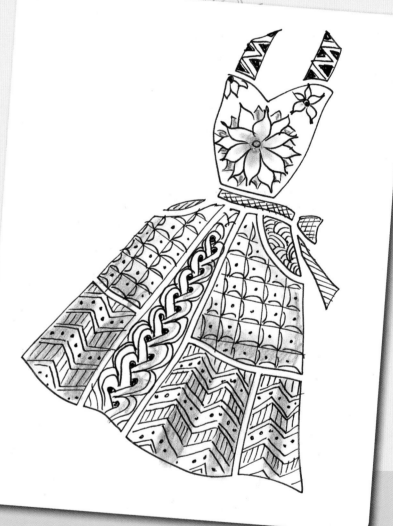

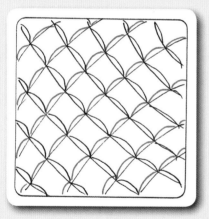

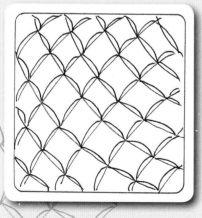

Chillon

(original by Rick Roberts and Maria Thomas)

This is similar to Bales but even easier as it is done on only two sides of the square in the grid. I used the Apron Dreamweaver stencil.

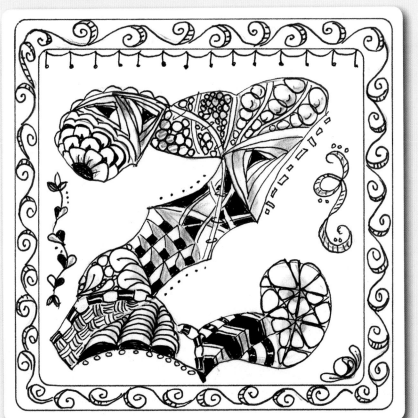

Coral Seeds

(original by Suzanne McNeill CZT of Design Originals)

I love this tangle by Suzanne – it is so simple and the variation is good, too. I have used lots of other tangles here, too – see if you can identify them.

Crescent Moon
(original by Rick Roberts and Maria Thomas)

This is very often the first tangle that people learn. It is easily varied depending on whether you make the 'moons' solid or not, and how many halos you do around the moon. Shading makes a big difference – I like to do it between the moons.

Tangles used:
Hollibaugh, N'Zeppel,
Crescent Moon.

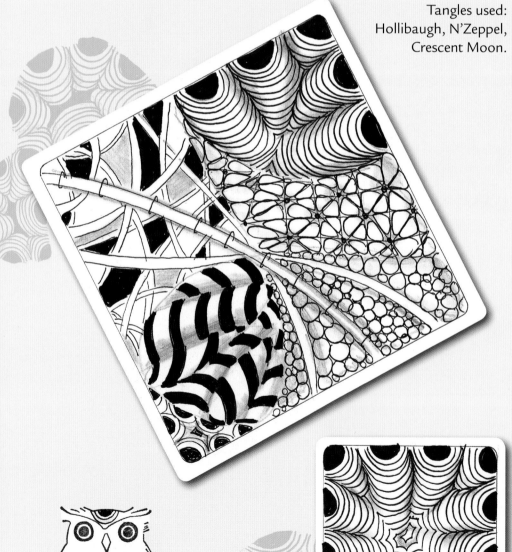

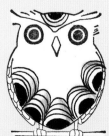

Cruffle

(original by Sandy Hunter CZT)

This is a wonderful tangle and one of my favourites. It is a lot of fun to create, either freehand or even using a template to draw lots of different-sized circles and then connecting them with Flux. I love adding Cruffle to cards, bookmarks and tags.

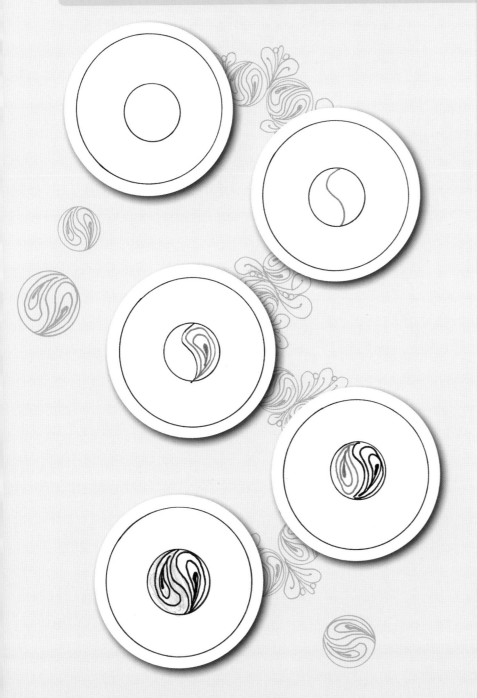

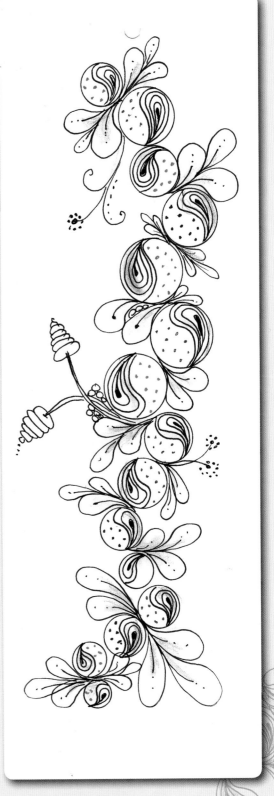

Tangles used on bookmark:
Cruffle, Flux and Zinger.

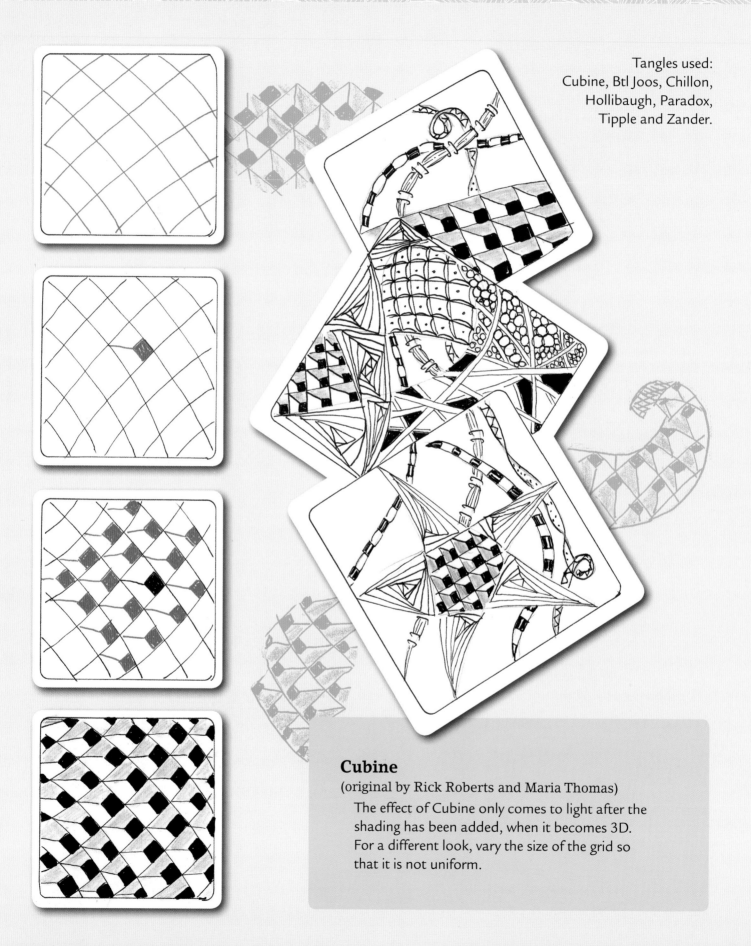

Tangles used:
Cubine, Btl Joos, Chillon,
Hollibaugh, Paradox,
Tipple and Zander.

Cubine
(original by Rick Roberts and Maria Thomas)
 The effect of Cubine only comes to light after the
 shading has been added, when it becomes 3D.
 For a different look, vary the size of the grid so
 that it is not uniform.

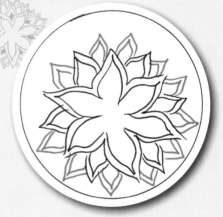

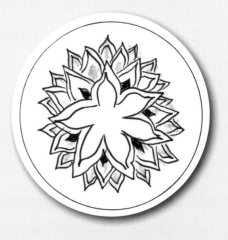

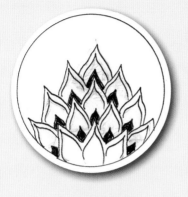

Cyme
(original by Rick Roberts and
Maria Thomas)

Cyme creates a nice flowery
effect. I have used it in the
vase only above Verdigogh.

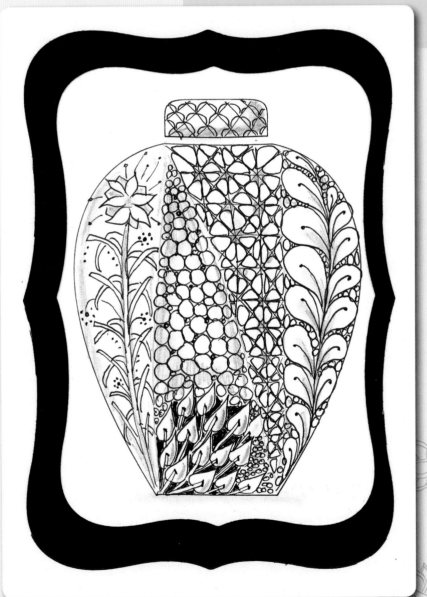

Tangles used:
Verdigogh, Tipple, Poke Leaf, N'Zeppel, Flux
and Bales on the lid.

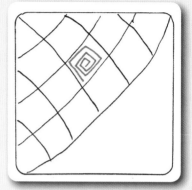

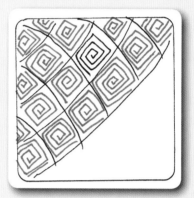

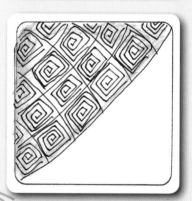

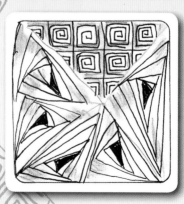

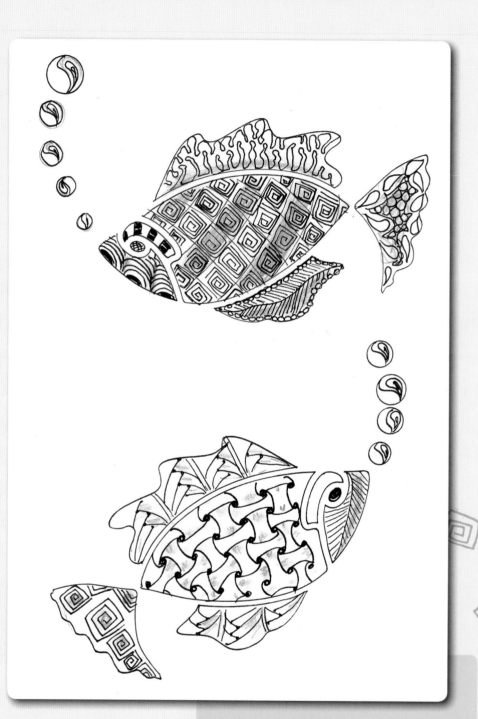

Tangles used:
Fish 1 – Emingle, Crescent Moon, Quabog, Ennies (tail) and Meer.
Fish 2 – Huggins, Betweed, Emingle and Meer.
Bubbles: Cruffle.

Emingle
(original by Rick Roberts and Maria Thomas)

Don't make your grid too small as Emingle is much easier to do with a larger grid.

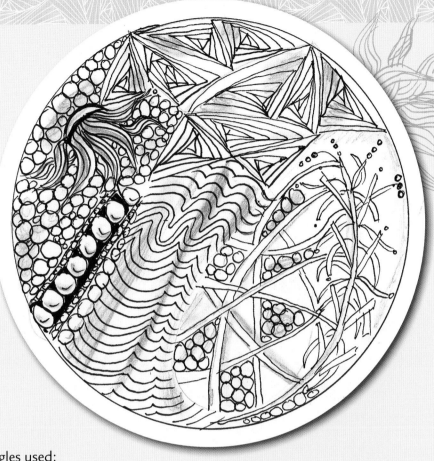

Tangles used:
Emingle, Tipple, Onamato,
Static, Hollibaugh, Verdigogh
and Paradox.

Enyshou
(original by Rick Roberts and
Maria Thomas)

I like to do this one on
a piece of card with a
watercolour background.
Sprinkling some sea salt on
it while wet and shaking it
off when dry gives a really
nice effect, and the tangle
can then be done on
top of it.

Fife

(original by Molly Hollibaugh)

Molly is Maria's daughter, a very talented and experienced CZT. She has done a lot of work with schoolchildren. Another of her tangles worth looking up is Indy-rella, which was named with her daughter, Indiana, in mind.

For these tiles I used my multi-square template to create the strings. I left some blank for effect and used lots of different tangles to fill the spaces: BB, Btl Joos, Fengle, Florz, Flux, Paradox and Tipple.

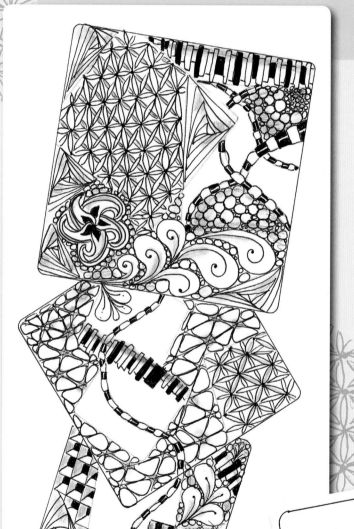

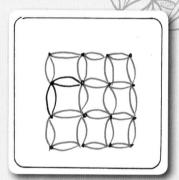

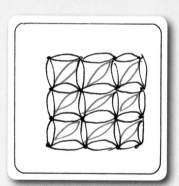

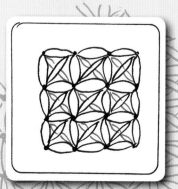

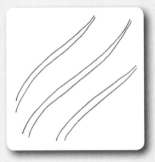

Finery

(original by Rick Roberts and Maria Thomas)

In this example I have used Dreamweaver's Zen Butterfly, which is a lovely new addition to Lynell Harlow's stencils. This tangle is very delicate-looking and perfect for the wings of the first butterfly, along with Festune for the lower wings. The second butterfly has N'Zeppel for the upper wings and Web for the lower wings.

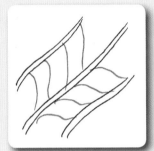

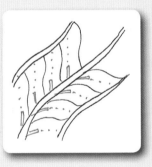

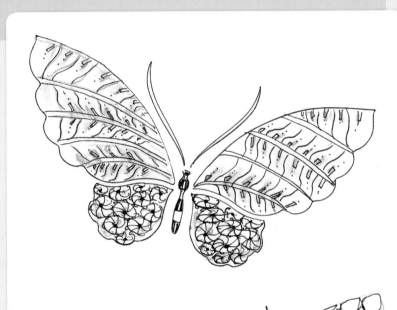

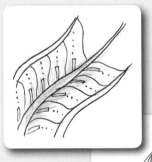

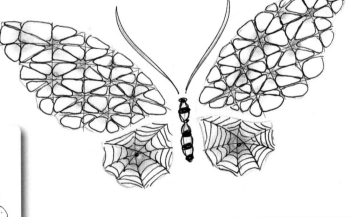

Tangles used:
Fish: Florz.
Owl: Meer, Keeko
(ear) Betweed (eyelids)
Mooka (wings), Florz
and Btl Joos.

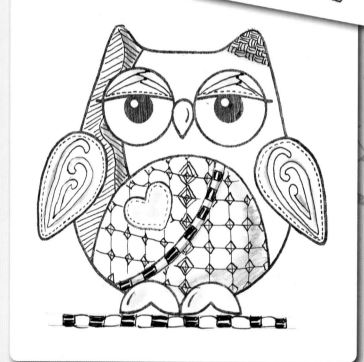

Florz

(original by Rick Roberts and Maria Thomas)

This is a light and airy tangle, useful for filling in large spaces. I have used Woodware's Fish and Owl stamps to illustrate the pattern; for the fish it is the standard tangle and for the owl it is a variation where the diamonds are not filled in.

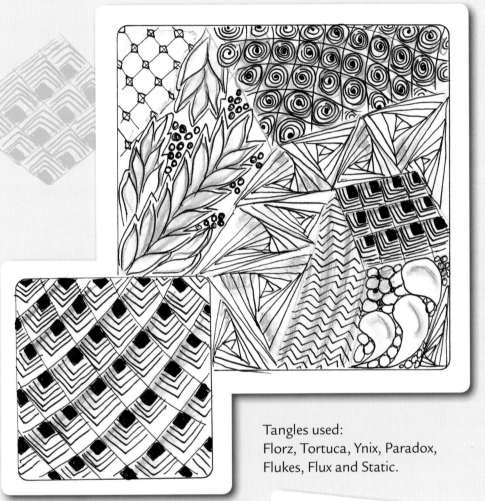

Tangles used:
Florz, Tortuca, Ynix, Paradox,
Flukes, Flux and Static.

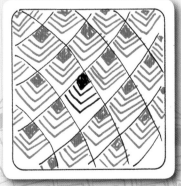

Flukes

(original by Rick Roberts and
Maria Thomas)

The artwork was done using
TanglePatterns String No. 084.

While filling in the spaces with tangles I decided to add
some triangles so that I could do a row of Paradox; these
triangles are marked with a dotted line so that you can
see where I have deviated from the original string.

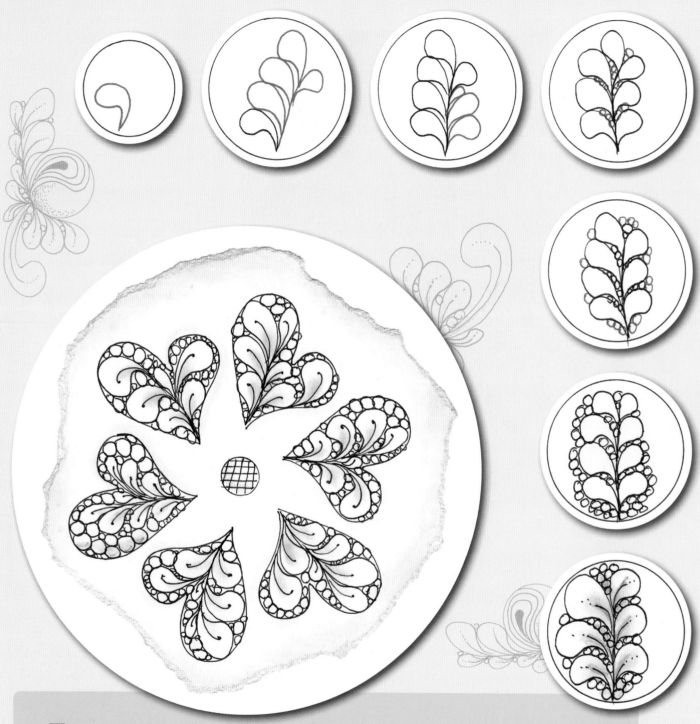

Flux

(original by Rick Roberts and Maria Thomas)

Probably my favourite tangle, Flux is a flowing leafy pattern which is open to a lot of variation depending on the size and shape of the 'leaves'. I used a Copic Marker in warm grey for the shading and Distress Ink to create the torn edge effect. A solitary Cruffle ball is in the middle.

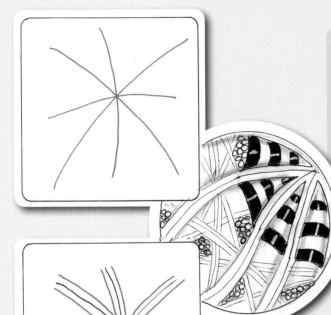

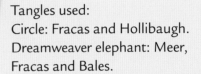

Fracas
(original by Rick Roberts and Maria Thomas)

You can add highlights to this one using a white Sakura Gelly Roll pen instead of leaving a gap as illustrated.

Tangles used:
Circle: Fracas and Hollibaugh.
Dreamweaver elephant: Meer, Fracas and Bales.

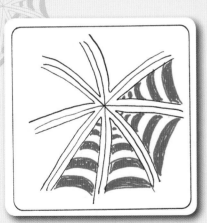

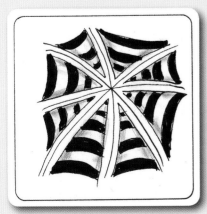

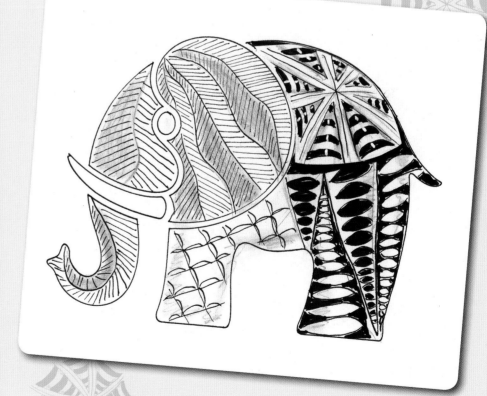

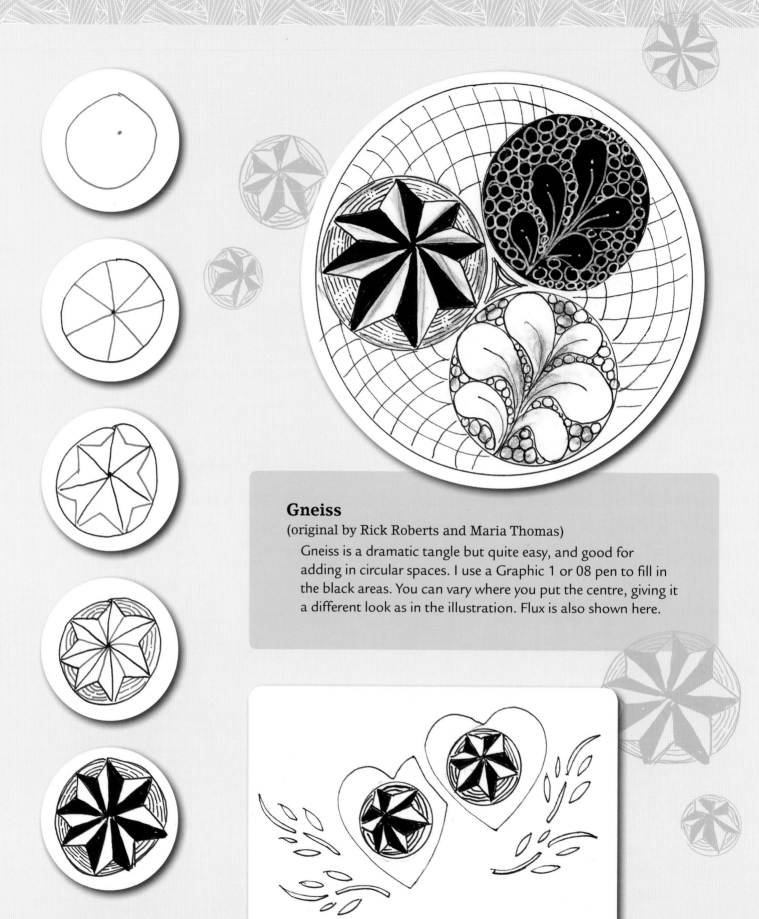

Gneiss

(original by Rick Roberts and Maria Thomas)

Gneiss is a dramatic tangle but quite easy, and good for adding in circular spaces. I use a Graphic 1 or 08 pen to fill in the black areas. You can vary where you put the centre, giving it a different look as in the illustration. Flux is also shown here.

Heartrope

(original by Bunny Wright)

I love Heartrope and use it often. It is very easy once you see it deconstructed, but it would not be so easy to copy without the step-outs. It can be used as a border, circular or straight. To illustrate it I have used a Kala Dala stencil which shows it up nicely, along with Printemps and Meer variation. You can 'halo' it once or multiple times for different effects.

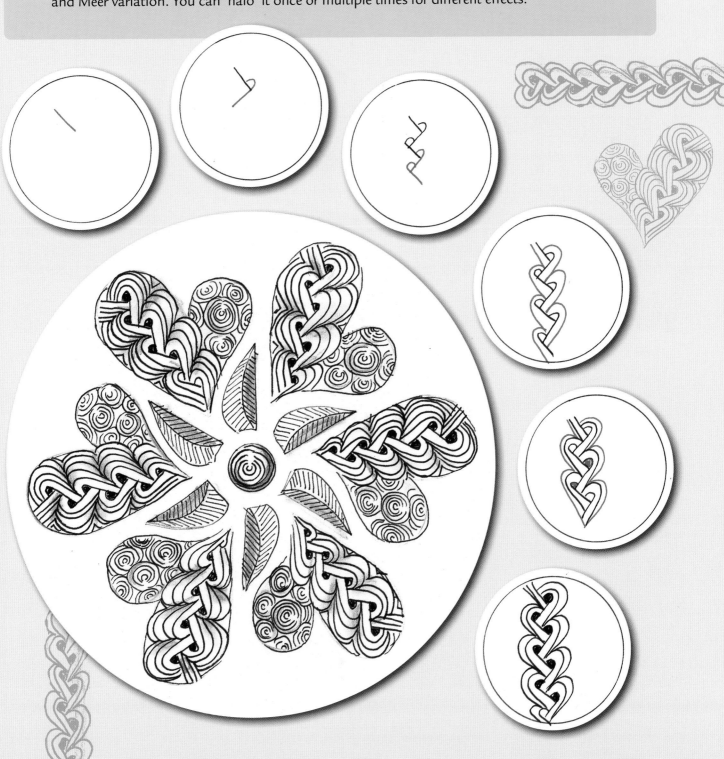

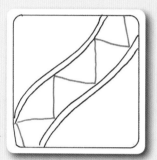

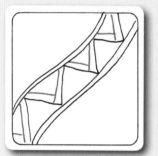

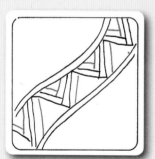

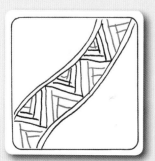

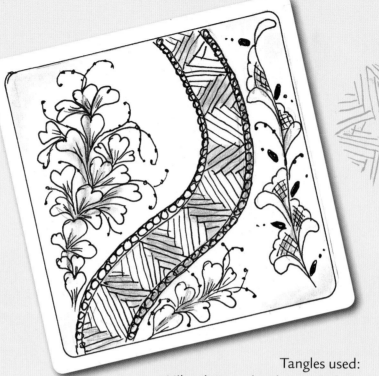

Tangles used:
Hibred, Luv-a by Sharon Caforio
CZT and Vigne by Sue Jacobs CZT.

Hibred

(original by Rick Roberts and Maria Thomas)

This makes a good pattern for a border – maybe for a frame or embellishing journals and notebooks.

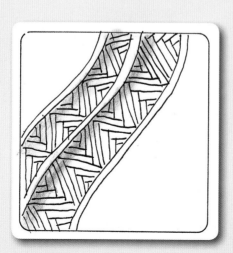

Hollibaugh

(original by Nick Hollibaugh)

Probably the most well-known of all tangles, Hollibaugh was created by Molly's husband, Nick, who used to draw a similar pattern as a child. For me this is the most relaxing tangle of all, and most of the people I teach say the same thing. It can be drawn in straight or curvy lines or a mixture of both. You can do as little or as much as you feel like. After drawing the first 'band' every line you draw goes under the line that it meets. The background can be left blank or filled in black.

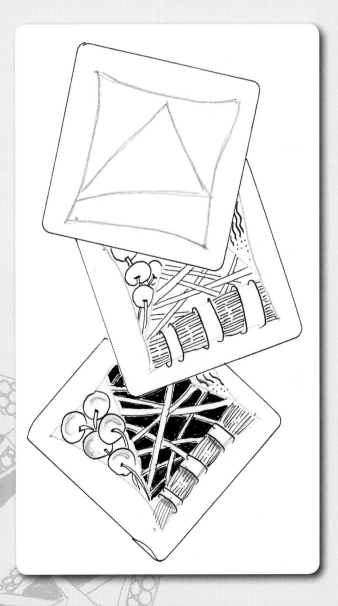

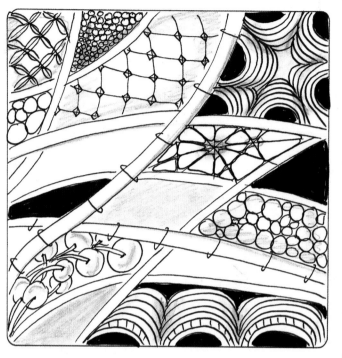

Hollibaugh string

Hollibaugh can be used as a string, filling in the spaces it creates with other tangles. Don't draw too many lines; leave enough space to tangle in some of the sections.

The first example uses Hollibaugh as a string and fills in with various tangles: Florz, Bales, Tipple, Crescent Moon, N'Zeppel and Poke Root.

For this second example I used a circular template to create the strings and then filled the spaces with various tangles – Tipple, Static, Flux, Paradox, Zander, and Hollibaugh with Tipple – and some black ink.

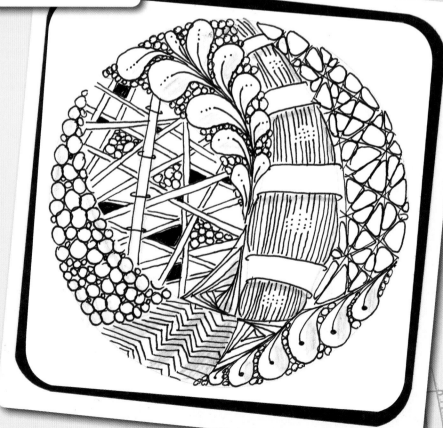

Huggins

(original by Rick Roberts and Maria Thomas)

Huggins is very similar to Cadent but rather than doing an S shape around the dots you will be doing more of a slim C shape – first a C and then a backward C. Alternately, go on the outside of the dots and then the inside, rotating your tile halfway. Shading gives it a much better look, whether with pencil or drawing fine lines with pen.

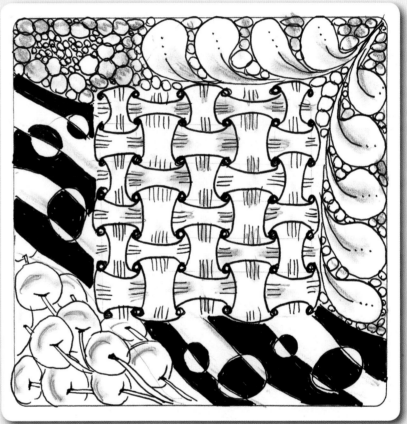

Tangles used:
Flux, Strickles, Huggins, Tipple and Poke Root.

Jetties

(original by Rick Roberts and Maria Thomas)

This tangle is created by making a series of circles and then drawing the tangle patterns inside them. Variations can be created by changing the size and number of circles and also the shading.

Tangles used: Jetties, Florz, N'Zeppel random, Ynix, Poke Leaf and Tipple.

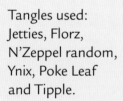

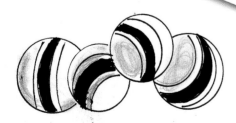

Jonqal

(original by Rick Roberts and Maria Thomas)

This stripey pattern is similar to Braze. The shading is particularly important. Jonqal can look dramatic in the middle of a large ZIA. I have used it here with Hollibaugh.

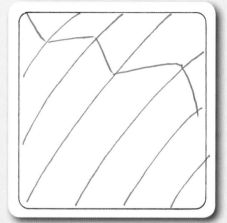

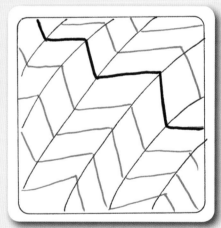

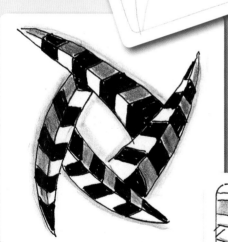

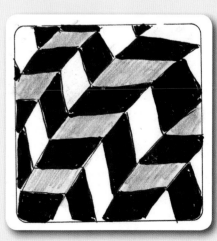

Joy
(original by Joyce Block CZT)

Never underestimate the power of a simple pattern. I met Joyce, who comes from Oconomowoc, Wisconsin, in the UK, where her daughter lives. She kindly gave me a gift of Rick and Maria's *Book of Zentangle*, which contains some beautiful artwork. Joyce teaches with her Zentangle partner, Don McCullum.

Joy adds a bit of sparkle to your Zentangle art – it is very aptly named. You can add one or lots of them in different sizes.

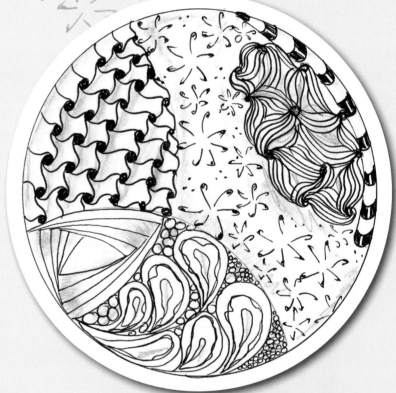

Tangles used:
Cadent, Joy, Flux variation, Paradox and Btl Joos.

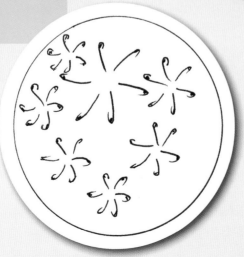

Kathy's Dilemma

(original by Rick Roberts and Maria Thomas)

This is a good pattern for filling in – don't do too large an area as filling in the corners takes time.

The Dreamweaver elephant would make a lovely children's card.

Tangles used:
E – BB and KD.
Elephant – N'Zeppel,
Kathy's Dilemma and Braze.

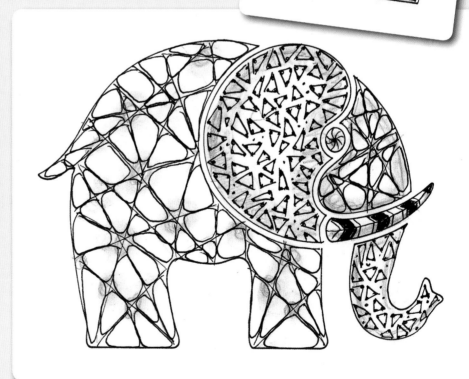

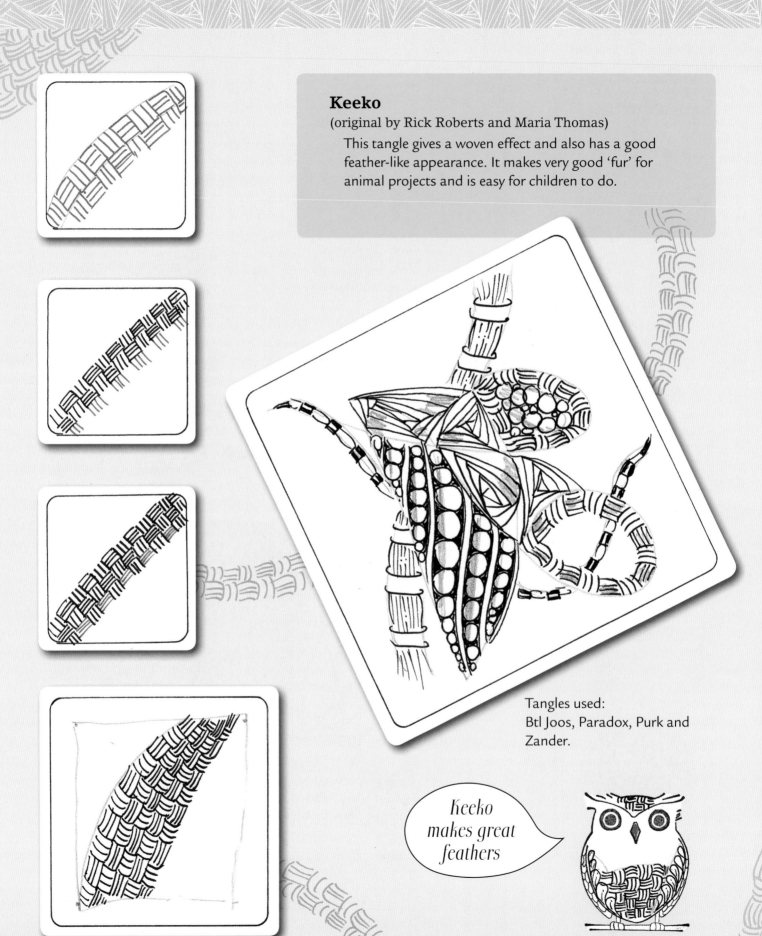

Keeko

(original by Rick Roberts and Maria Thomas)

This tangle gives a woven effect and also has a good feather-like appearance. It makes very good 'fur' for animal projects and is easy for children to do.

Tangles used:
Btl Joos, Paradox, Purk and Zander.

Keeko makes great feathers

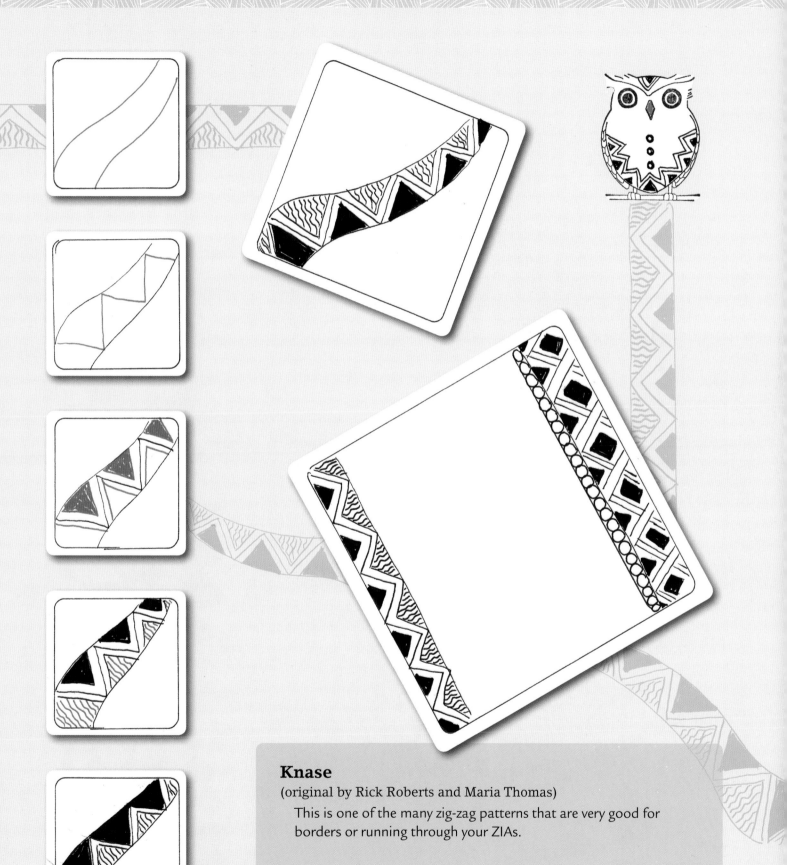

Knase

(original by Rick Roberts and Maria Thomas)

This is one of the many zig-zag patterns that are very good for borders or running through your ZIAs.

Knightsbridge

(original by Rick Roberts and Maria Thomas)

While this is an easy tangle, it needs care with the colouring-in. Vary the size of the grid for a different look.

Tangles used:
Tipple, Printemps, Hollibaugh, Cadent, Knightsbridge, Paradox, Poke Root, Msst, Joy, Crescent Moon variation and Man-O-Man.

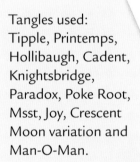

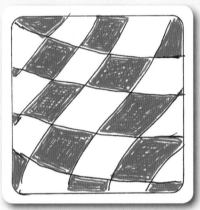

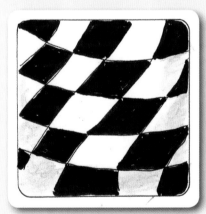

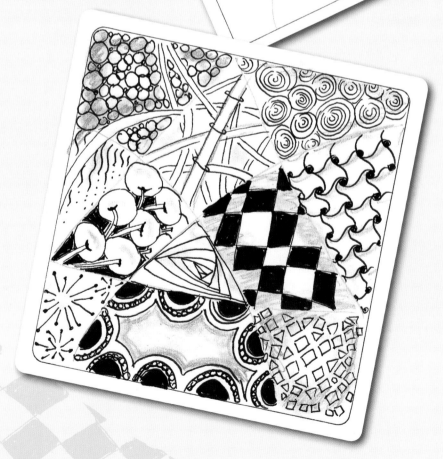

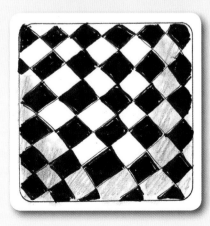

Man-O-Man

(original by Rick Roberts and Maria Thomas)

This looks easy, but it isn't and requires a bit of practice. Some people say it is easier to concentrate on the spaces between the shapes. Start with a small area and go from there.

Patience!

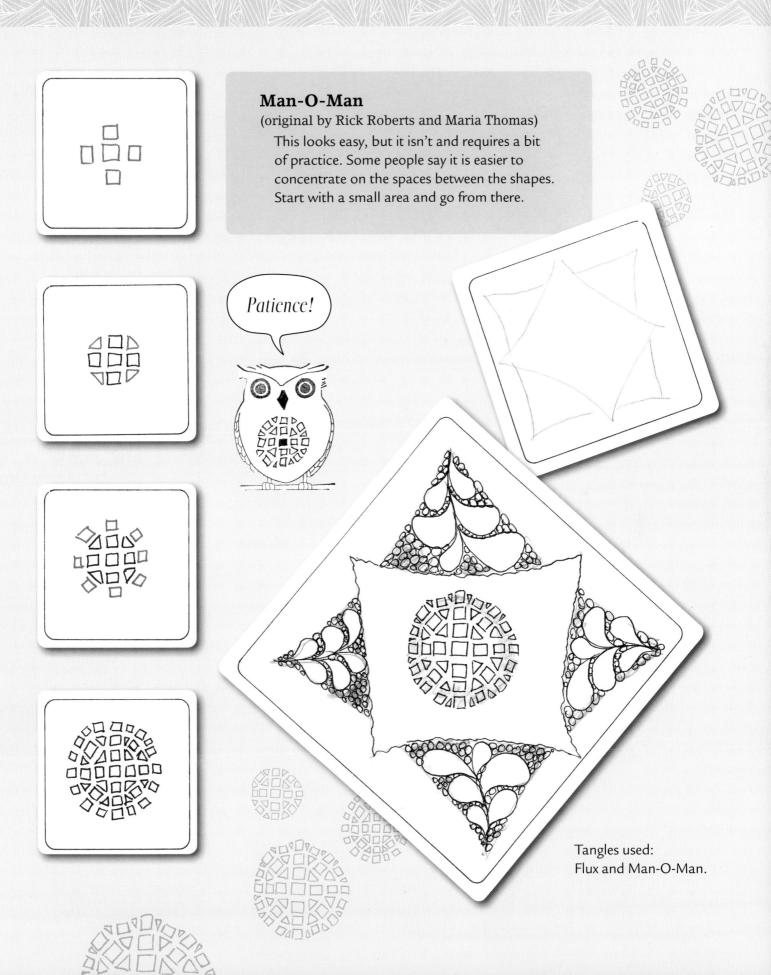

Tangles used:
Flux and Man-O-Man.

Marbaix

(original by Jane Marbaix CZT)

This is not an official tangle, just an idea I got from an envelope that came in the mail. I started drawing the 'spokes' going around in a circle. I couldn't get it looking right until I broke it up into segments rather than randomly going around the circle – easy!

I couldn't think of a name, so I chose mine! Try putting a small circle in pencil anywhere inside the larger circle (first illustration) and then follow the step-out from there. If the first tiny circle is off-centre it gives a more rounded look, as it does in the illustrations. I used Flux and Joy here as complements.

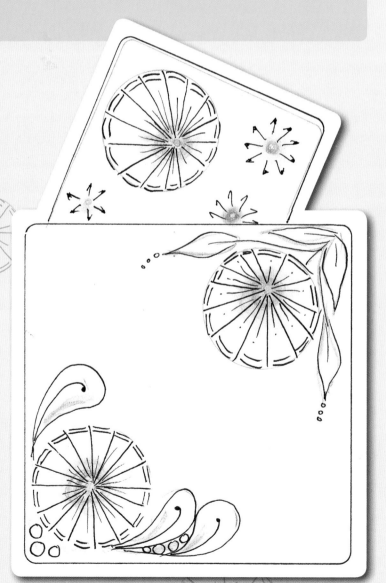

Meer
(original by Rick Roberts and Maria Thomas)

A nice easy tangle – a good one for filling in a narrow space and comes to life once the shading has been added to one side.

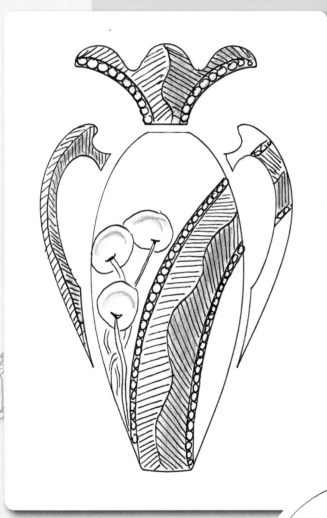

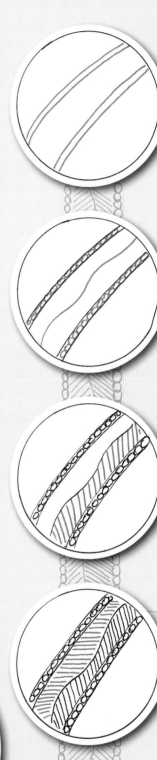

Tangles used in Dreamweaver vase: Meer and Poke Root.

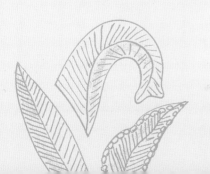

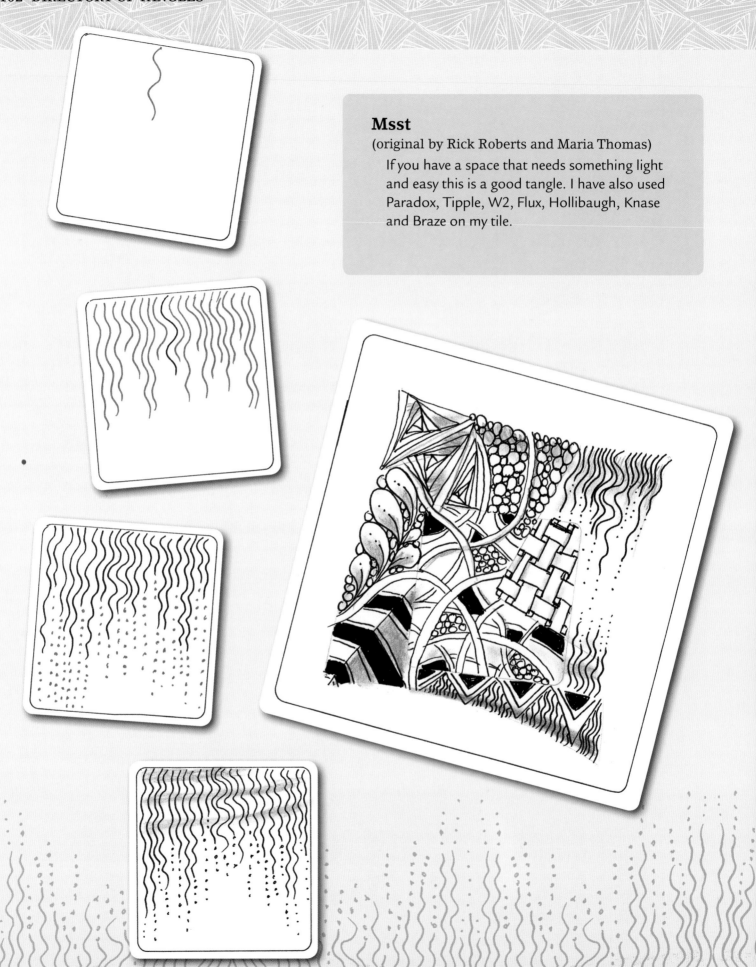

Msst

(original by Rick Roberts and Maria Thomas)

If you have a space that needs something light and easy this is a good tangle. I have also used Paradox, Tipple, W2, Flux, Hollibaugh, Knase and Braze on my tile.

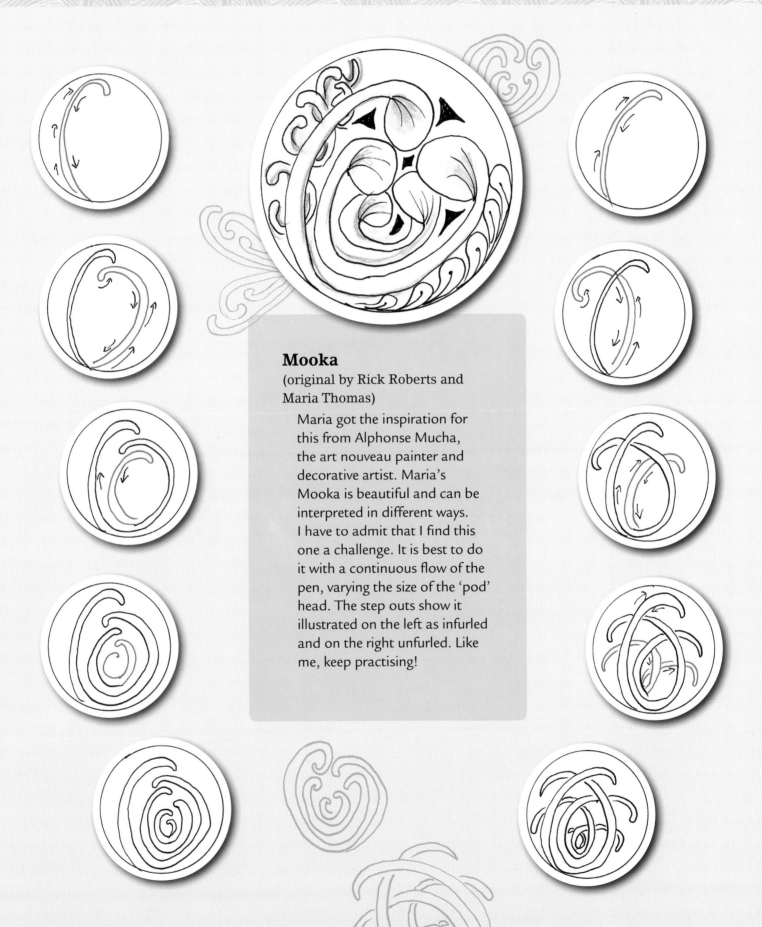

Mooka

(original by Rick Roberts and
Maria Thomas)

Maria got the inspiration for
this from Alphonse Mucha,
the art nouveau painter and
decorative artist. Maria's
Mooka is beautiful and can be
interpreted in different ways.
I have to admit that I find this
one a challenge. It is best to do
it with a continuous flow of the
pen, varying the size of the 'pod'
head. The step outs show it
illustrated on the left as infurled
and on the right unfurled. Like
me, keep practising!

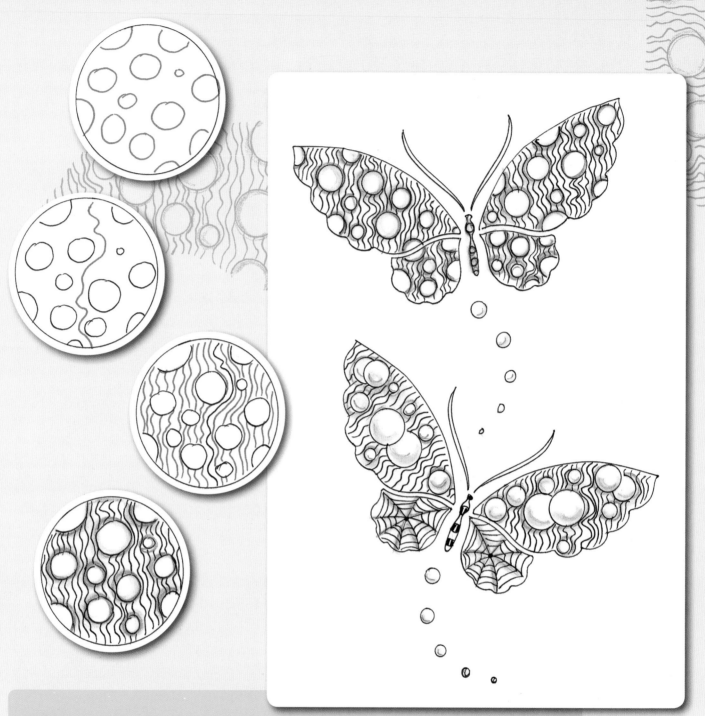

Nipa

(original by Rick Roberts and Maria Thomas)

This one is definitely all in the shading. You can either shade around the circles with your pencil and use your blending paper stump to soften it (first illustration) or shade the circles individually (second illustration). I love the look of Nipa on Dreamweaver's Zen Butterfly.

N'Zeppel

(original by Rick Roberts and Maria Thomas)

This is one of my very favourite tangles – it would be impossible to do without the step-out.

1. Start with a basic grid – don't put the lines too close together.

2. Next draw another line through the cross section.

3. Now rotate the tile and draw a line through the cross section again – basically there is a cross within a square.

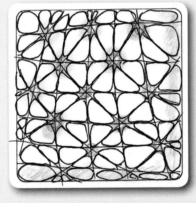

4. Next draw around the lines of the triangles formed, rounding off the corners.

5. Now shade it; I like to shade the middle of the 'flowers'.

Random N'Zeppel

This is done with lines randomly crossing over each other and then filling in the spaces, cutting off the corners as before.

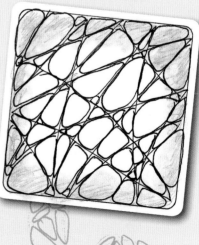

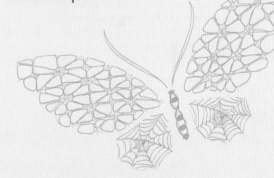

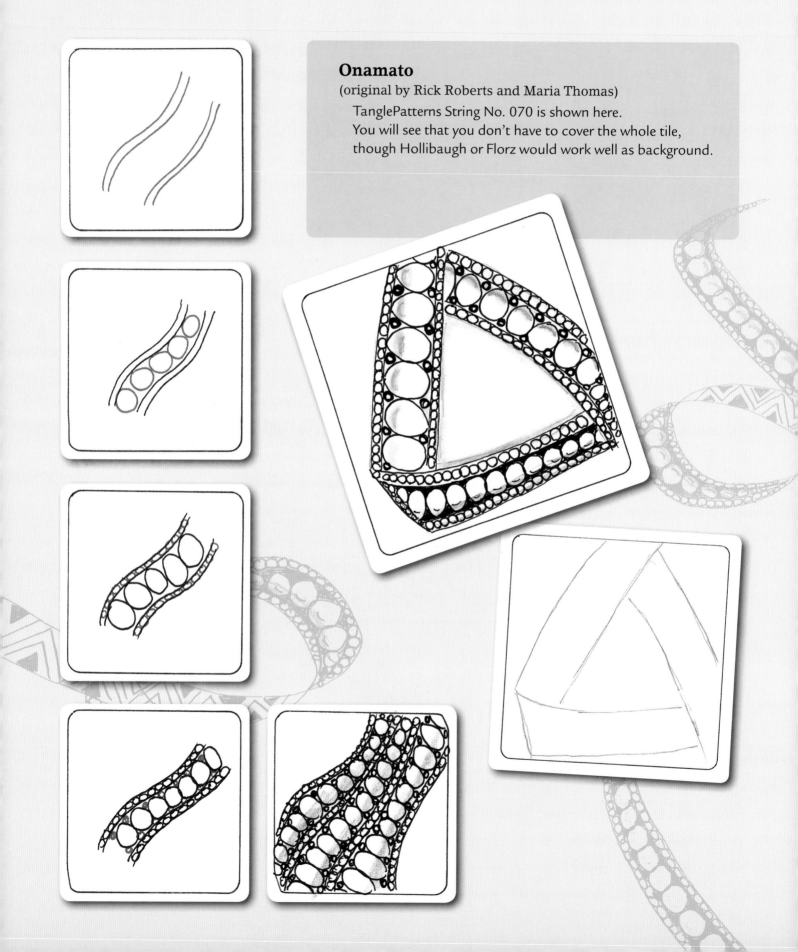

Onamato

(original by Rick Roberts and Maria Thomas)

TanglePatterns String No. 070 is shown here.
You will see that you don't have to cover the whole tile,
though Hollibaugh or Florz would work well as background.

Paradox

(original by Rick Roberts)

This is often known as Rick's Paradox!

It is one of the more fascinating tangles and certainly merits two pages. Not everyone 'gets' it first time of trying – I didn't when I saw it demonstrated on an overhead projector and then I had a very patient Rick personally show me how, followed by Maria showing me how! Now I can't stop!

This illustration is just a square divided into triangles – you wouldn't be able to guess where the strings were from seeing the finished Zentangle.

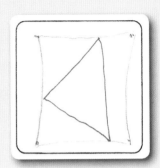

Rotate

Rotate

Rotate

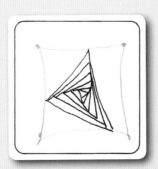

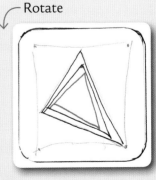

Rotate, rotate, rotate!

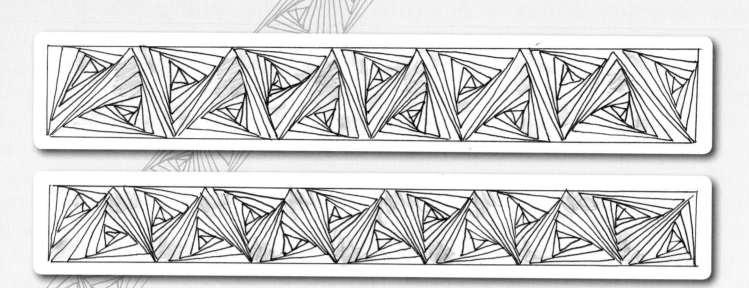

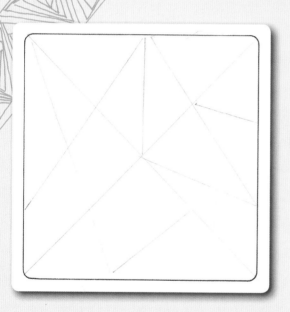

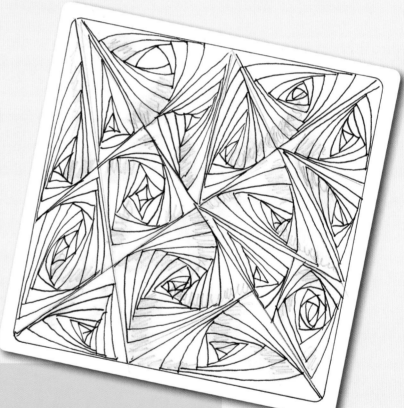

Paradox (continued)

This is a demonstration of how the Paradox pattern changes depending on which way round you draw it. The first example is just a border divided into triangles and then Paradox drawn in each triangle, all going clockwise. The second example is drawn with one Paradox going clockwise and the next one anti-clockwise, and so on. The third example is a square divided up into squares and triangles with Paradox going in either direction.

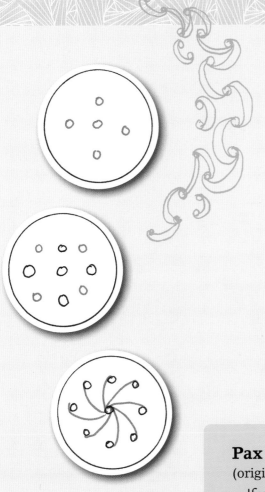

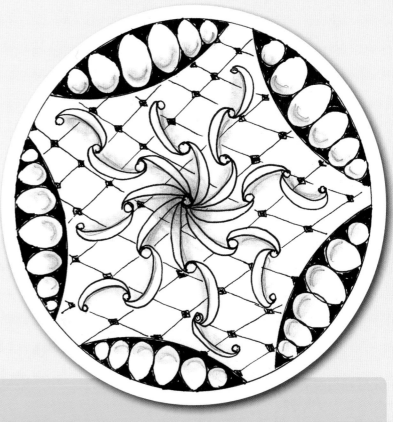

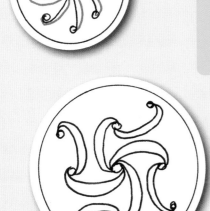

Pax

(original by Christine Reyes)

If you like Cadent, you will enjoy this one. Whereas with Cadent you do an S stroke around the circles, with Pax it is a C stroke (one right side up and the next one upside down). You can just go on joining one to another, which is what I love about it. It's quite effective with Florz in the background as illustrated.

Pinch

(original by Rick Roberts and Maria Thomas)

The only caution I would urge with this tangle is that the smaller you make it the more difficult it is.

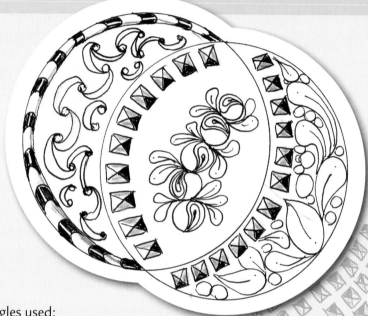

Tangles used:
Circles – Btl Joos, Pax, Pinch, Flux and Cruffle.
Fish by Dreamweaver – Pinch, Crescent
Moon variation, Meer and Cadent.

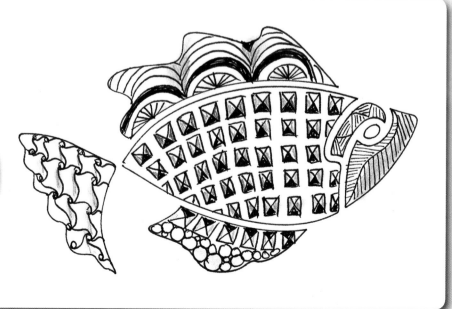

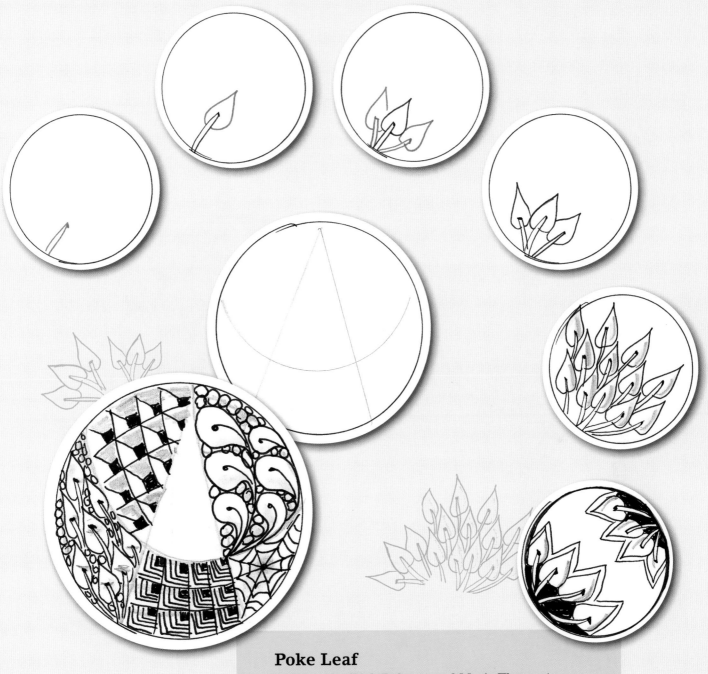

Poke Leaf

(original by Rick Roberts and Maria Thomas)

This is similar to Poke Root (see overleaf).

The illustration shows Poke Leaf, Flukes, Cubine, Web and Flux and a halo around the Poke Leaf.

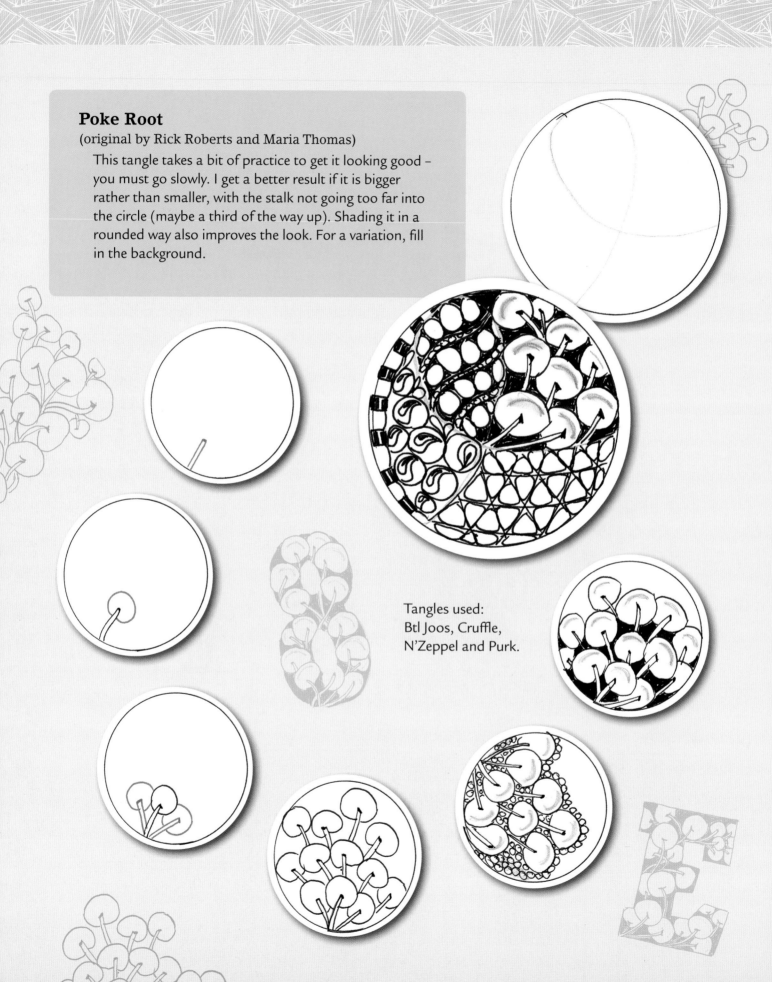

Poke Root

(original by Rick Roberts and Maria Thomas)

This tangle takes a bit of practice to get it looking good – you must go slowly. I get a better result if it is bigger rather than smaller, with the stalk not going too far into the circle (maybe a third of the way up). Shading it in a rounded way also improves the look. For a variation, fill in the background.

Tangles used:
Btl Joos, Cruffle,
N'Zeppel and Purk.

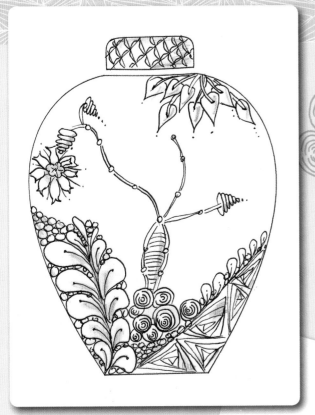

Tangles used:
On the jar, Flux, Paradox and
Poke Leaf, with Chillon on
the lid; On the boot, Crescent
Moon, Knightsbridge and
N'Zeppel Random.

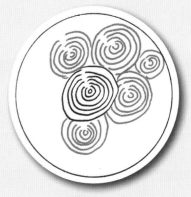

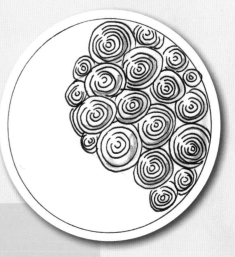

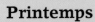

Printemps

(original by Rick Roberts and Maria Thomas)

This circular tangle has a highlight – a small gap left in the circle. Shade it in a circular fashion to round it. I used part of the Dreamweaver boot stencil.

I sometimes type a small verse and place it inside the Ginger Jar by putting the stencil over the verse and doing the outline, then tangling around the verse.

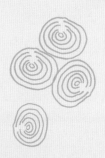

Purk

(original by Rick Roberts and Maria Thomas)

This is a popular tangle for filling in oval spaces. The Dreamweaver Vase stencil is used here with Verdigogh, Btl Joos for the handles and Printemps for the lid.

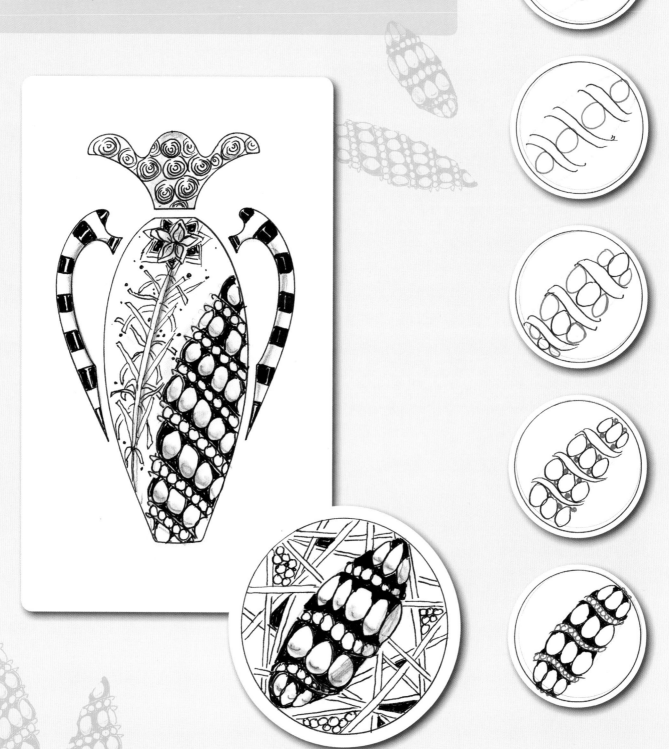

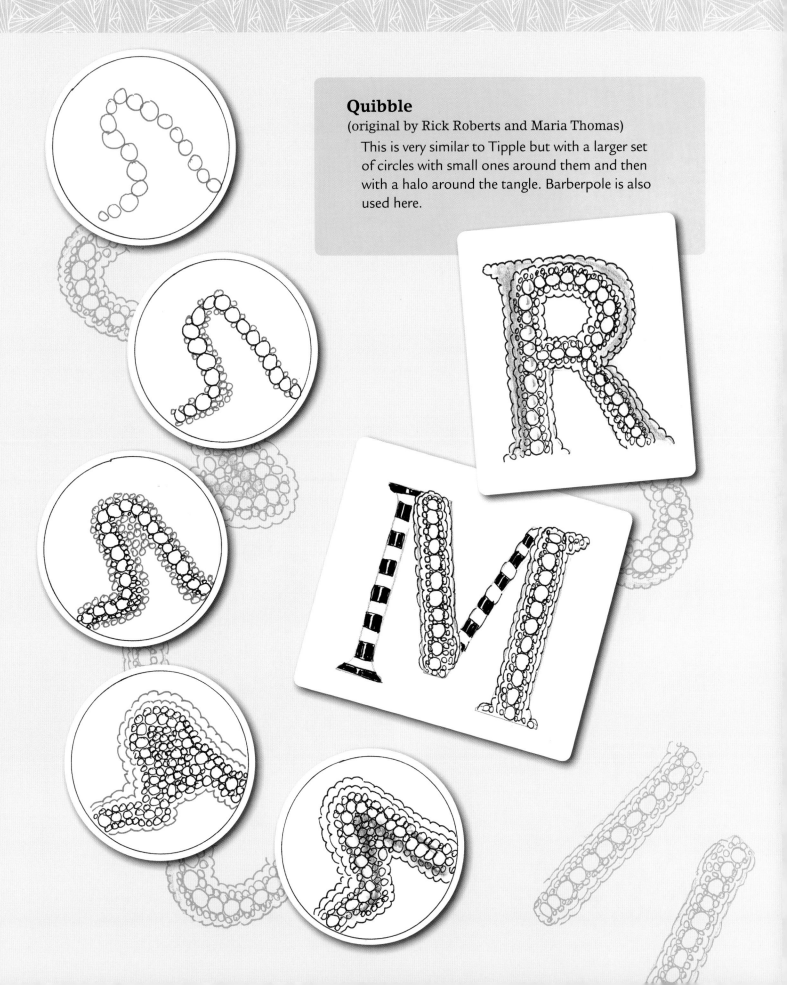

Quibble

(original by Rick Roberts and Maria Thomas)

This is very similar to Tipple but with a larger set of circles with small ones around them and then with a halo around the tangle. Barberpole is also used here.

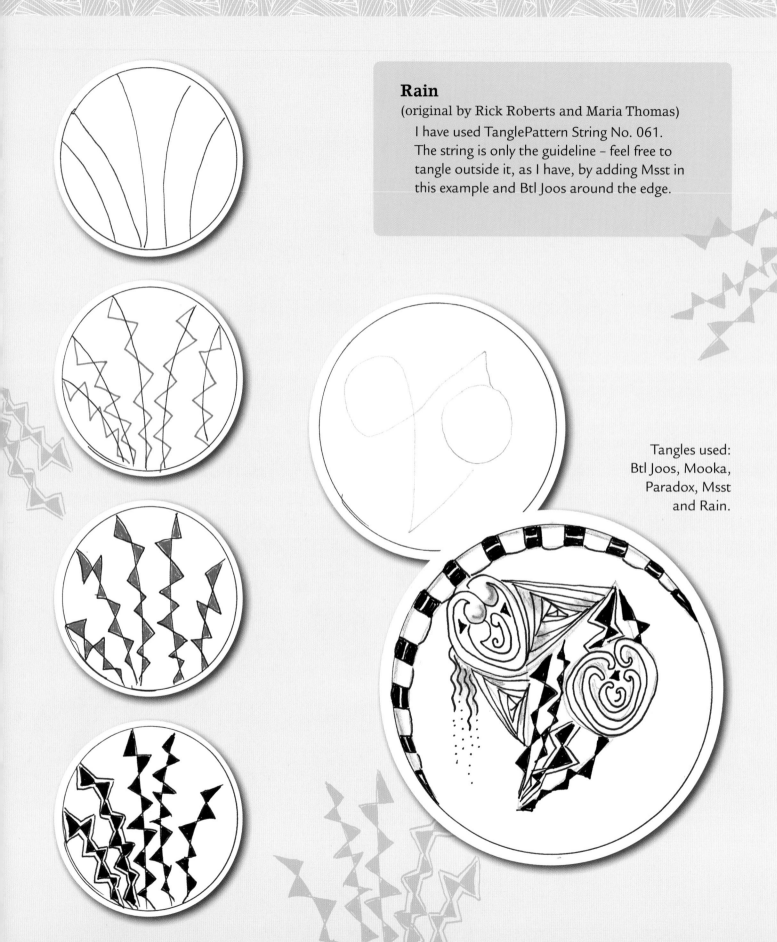

Rain

(original by Rick Roberts and Maria Thomas)

I have used TanglePattern String No. 061. The string is only the guideline – feel free to tangle outside it, as I have, by adding Msst in this example and Btl Joos around the edge.

Tangles used:
Btl Joos, Mooka,
Paradox, Msst
and Rain.

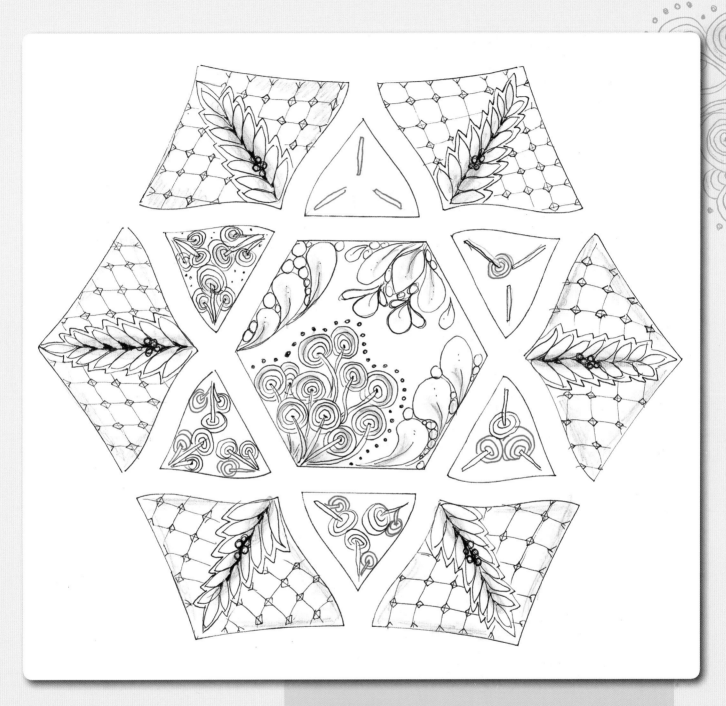

Tangles used:
Flux, Florz variation, Ynix and
Sedgling surrounded by Perfs.

Sedgling

(original by Rick Roberts and Maria Thomas)

This is similar to Poke Root but has several circles
drawn around the stalk. I have used the centre
of a Kala Dala Demo stencil to do the step-out
clockwise around the stencil.

Squid

(original by Rick Roberts and Maria Thomas)

This is a nice flowery tangle. I have used a circle template to draw the strings inside the larger circle.

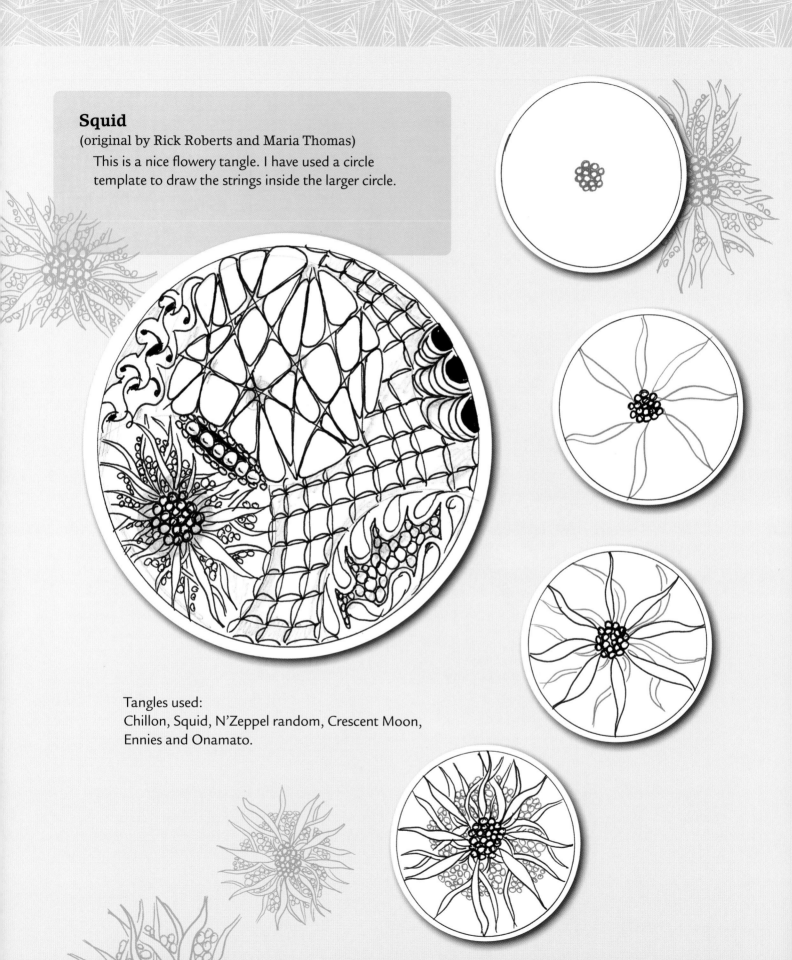

Tangles used:
Chillon, Squid, N'Zeppel random, Crescent Moon, Ennies and Onamato.

Rotate

Static

(original by Rick Roberts and Maria Thomas)

Static is a tangle that comes to life after shading, which gives a 3D effect. Try to make the lines fairly even for a pleasing result. For a variation draw curvy lines, but these will be a little harder to shade. If you start in the middle of your space and tangle one way and then rotate the tile to do the other half, you will find the process easier.

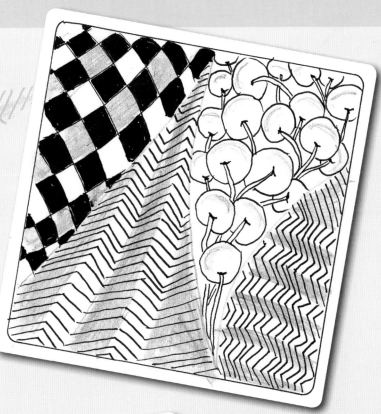

Shade

Tangles used:
Knightsbridge, Static
and Poke Root.

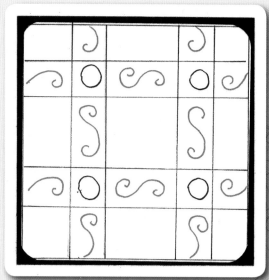

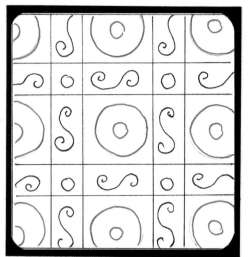

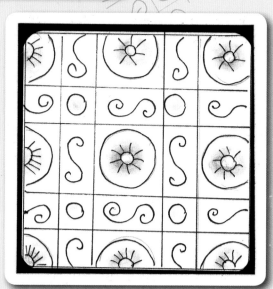

TA – SF

Looking for inspiration from art and nature is what we find ourselves doing after learning the Zentangle Method. Patterns are everywhere. On a trip to San Francisco in 2013, I visited an exhibition of the Terracotta Army at the city's Asian Art Museum. There was so much inspiration there, including a plaque on the wall with a wonderful pattern. It is so easy that it doesn't really need a step-out, but I've done a simple one anyway. It is one that you might use in a small area, or even just part of it. Keep looking for patterns!

Tangles used: Btl Joos and Poke Leaf.

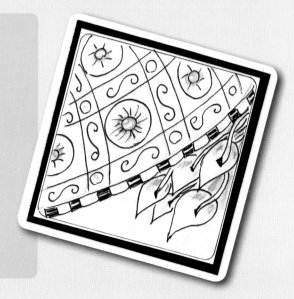

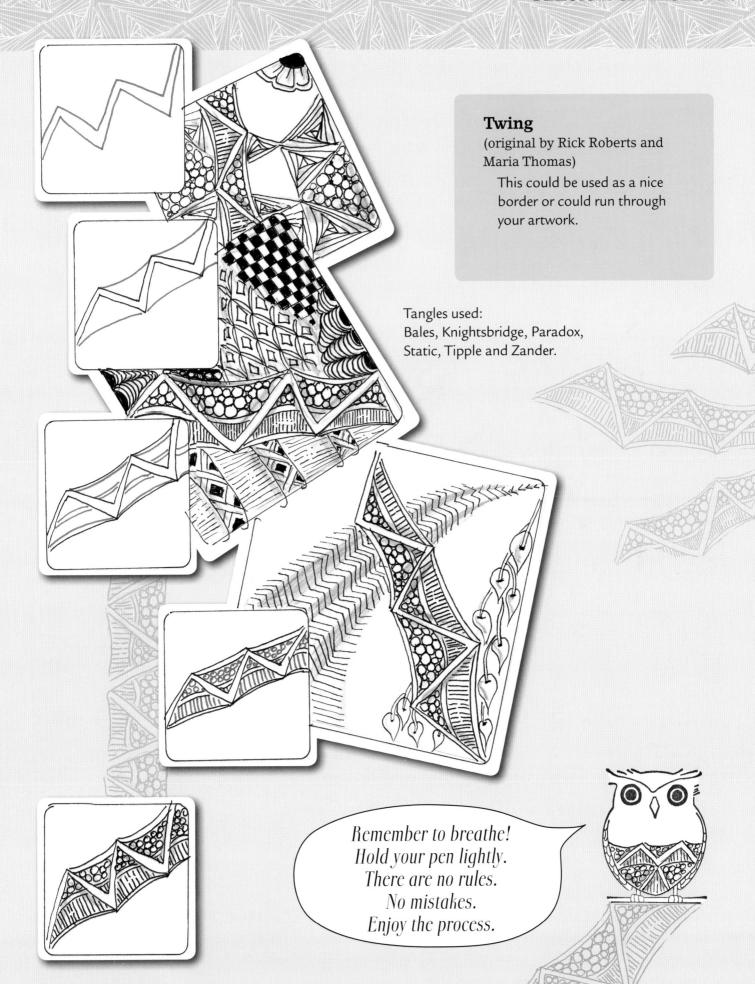

Twing
(original by Rick Roberts and Maria Thomas)
This could be used as a nice border or could run through your artwork.

Tangles used:
Bales, Knightsbridge, Paradox, Static, Tipple and Zander.

Remember to breathe!
Hold your pen lightly.
There are no rules.
No mistakes.
Enjoy the process.

Verdigogh

(original by Rick Roberts and Maria Thomas)

Verdigogh is a lovely leafy tangle. You could make a little garden with this one.

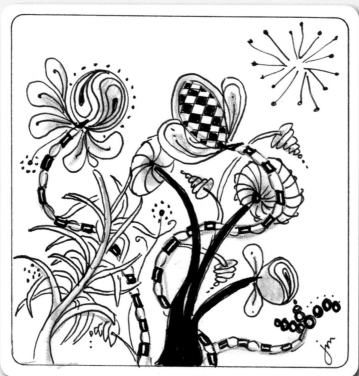

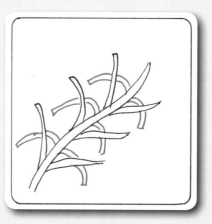

Tangles used:
Verdigogh, Cruffle, Btl Joos, Zinger and Ahh.

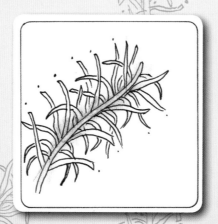

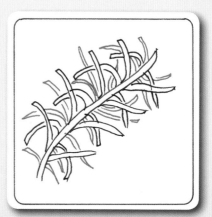

1. Make a set of squares in rows.

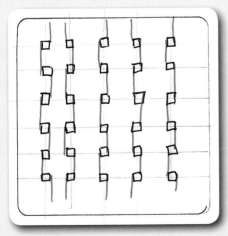

2. Join with lines – one inside the square, one outside.

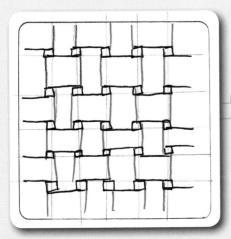

3. Rotate and do the same thing again, being careful to start in the right place. If in doubt, use pencil first to make sure you get the woven look – this won't happen if you start off wrong.

W2

(original by Rick Roberts and Maria Thomas)

For this artwork I found a patchwork template that I had for years. I drew around it and then, to make the strings, drew lines from corner to corner and put a circle in the middle.

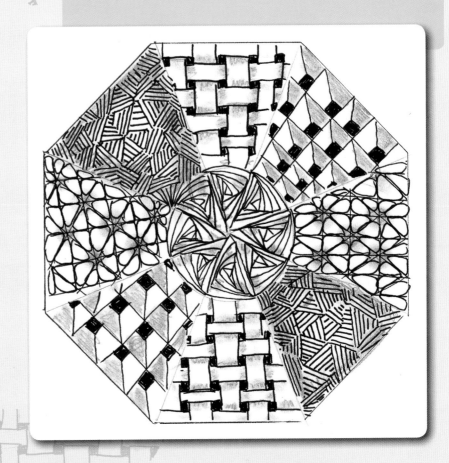

Tangles used:
Paradox in the middle and W2, Cubine, N'Zeppel and Shattuck variation.

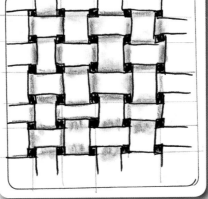

4. Shade the squares.

X Petal

(original by Sandra K Strait of Oregon, www.lifeimitatesdoodles.blogspot.com)

I have used part of a Kala Dala Demo stencil for this tangle. I didn't find it easy at first and thought 'When in doubt, pencil it out', so I drew the tangle in pencil and then went over it with my pen. Sandra's blogspot is well worth a look.

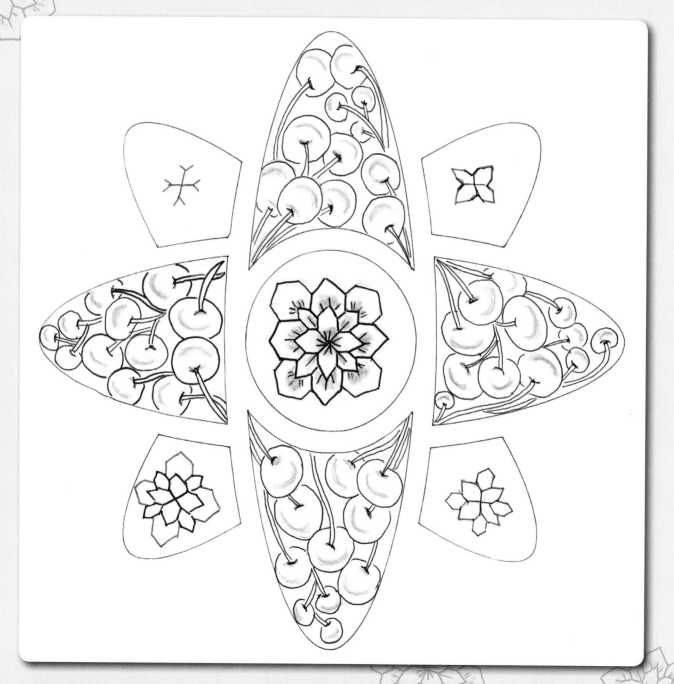

Tangles used:
X Petal and Poke Root.

Yincut

(original by Rick Roberts and Maria Thomas)

This tangle is all about the shading as it looks really flat without it. Leave a few highlights and shade along the grid lines.

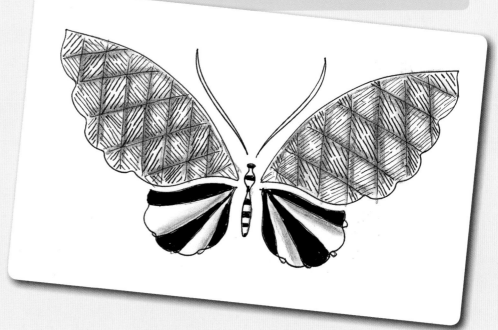

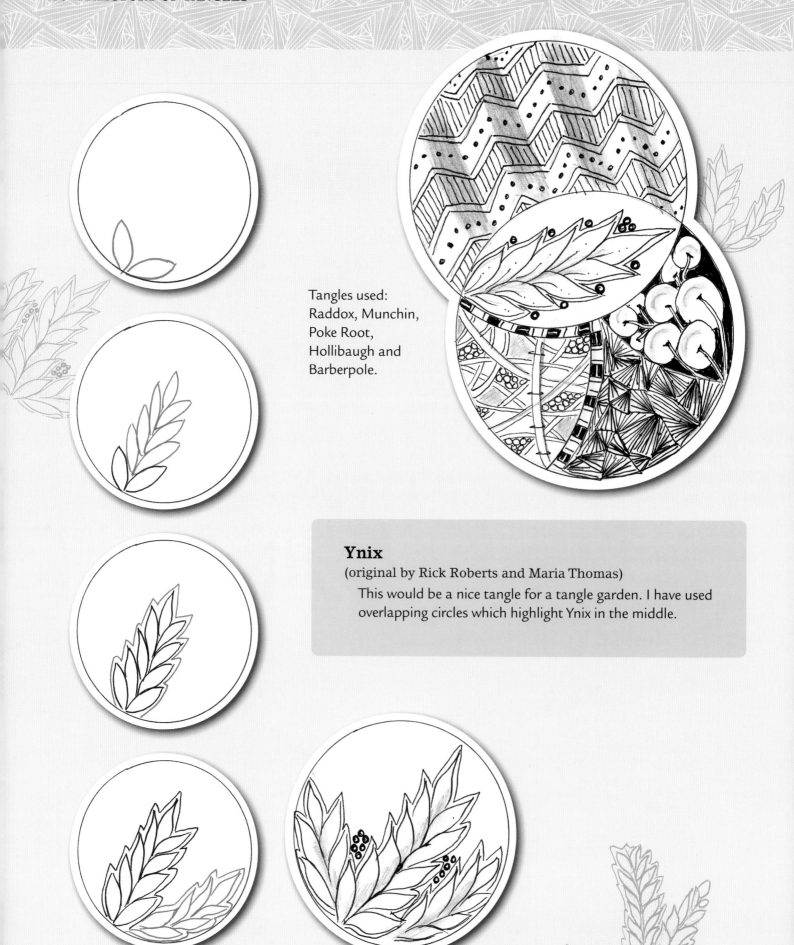

Tangles used:
Raddox, Munchin,
Poke Root,
Hollibaugh and
Barberpole.

Ynix

(original by Rick Roberts and Maria Thomas)

This would be a nice tangle for a tangle garden. I have used overlapping circles which highlight Ynix in the middle.

Zander

(original by Rick Roberts and Maria Thomas)

Zander is definitely a favourite of mine. I love running it through ZIAs and then doing tangles around it. Putting highlights in makes it look more rounded. Shade on one side of the 'band'. Decorate the bands for a different effect.

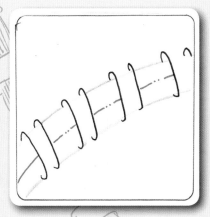

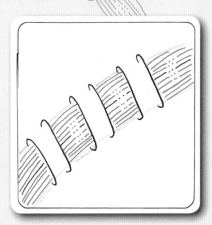

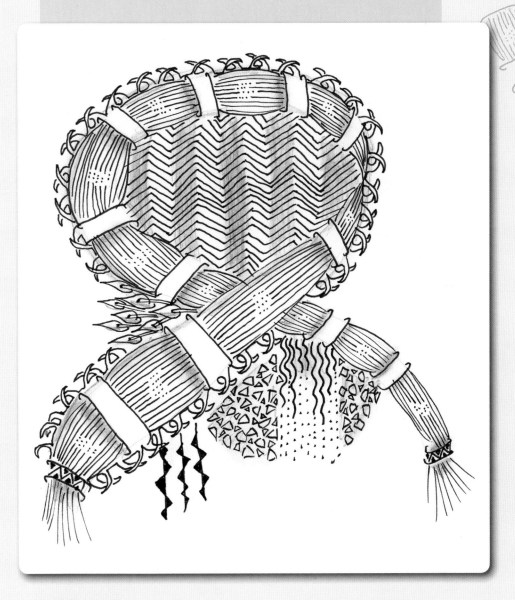

Tangles used:
Locar by R & M, Static, Zander, Rain and Msst.

Framing a quote

Sometimes I like to find a quote, choose a suitable font and print it in the middle of some card and then tangle around it. The quote for this frame is a fitting end to the book.

If you have enjoyed this book and would like to continue tangling, try to find a CZT in your area to take classes; a list of qualified CZTs can be found at www.zentangle.com

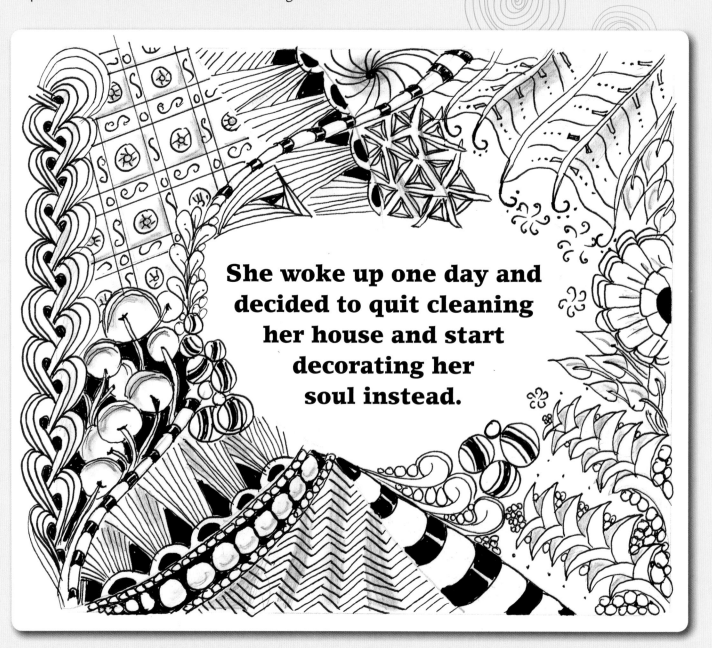

She woke up one day and decided to quit cleaning her house and start decorating her soul instead.

Tangles used:
Barberpole, Btl Joos, Dooleedo, Finery, Flux, Footlight, Heartrope, Jetties, Joy, Onamato, Paradox, Poke Leaf, Poke Root, Static, and TA-SF.